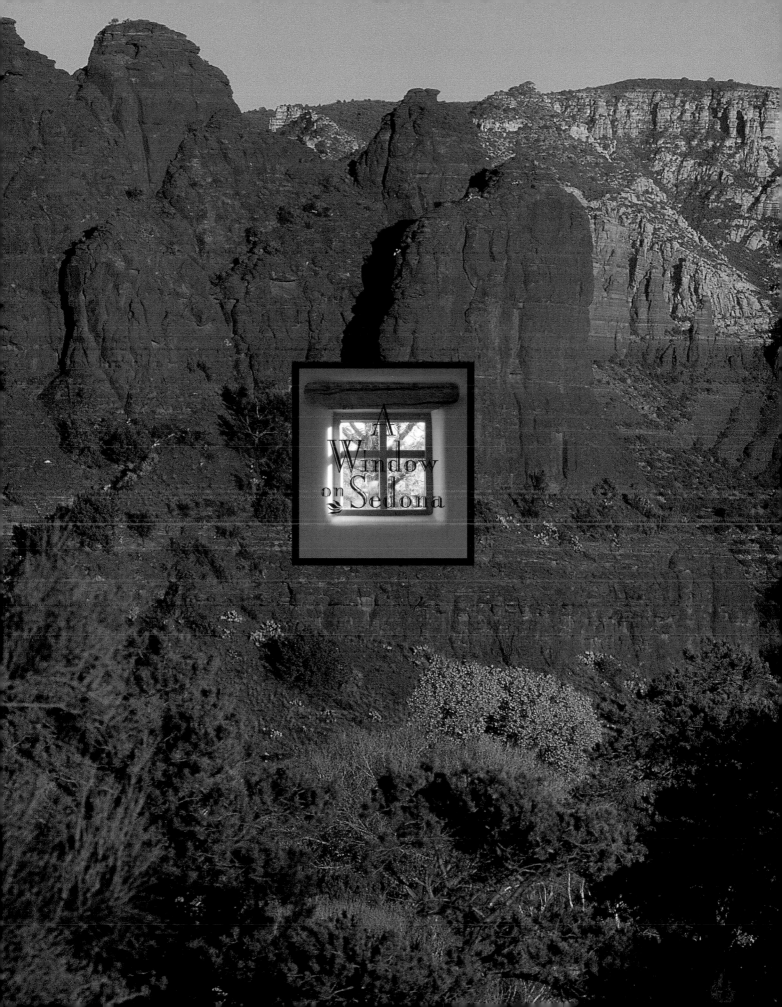

A
Window
on Sedona

LIVING
IN THE LAND
OF THE
RED ROCKS

A WINDOW ON

Sedona

Dottie Webster and Pamela Morris

Photography by Paula Jansen Editing and design by Carol Haralson

To David Webster, Phil Morris,
David Jansen, and Ed Wade, and to
our children and families, for their
inspiration and support.

Photographs by Paula Jansen ©1999 Paula Jansen
All photos are by Paula Jansen except page 105 by Bill Landing; pages
22, 23, 30, 35 (bottom right), 36, 55, 60 (left), 62, 115 by Dottie
Webster; and page 105 by Phil Morris.

Editing, design, and manufacturing supervision by Carol Haralson
Printed in Hong Kong through Colorprint
ISBN Number 0-9672265-0-3
Library of Congress Card Catalog Number 99-63271

CINNAMON STONE PUBLISHING, LLC

Post Office Box Number 4189

Sedona, Arizona 86340

e-mail: cinnamon@sedona.net

The House does not frame the view.

It projects the beholder into it.

HARWELL HAMILTON HARRIS

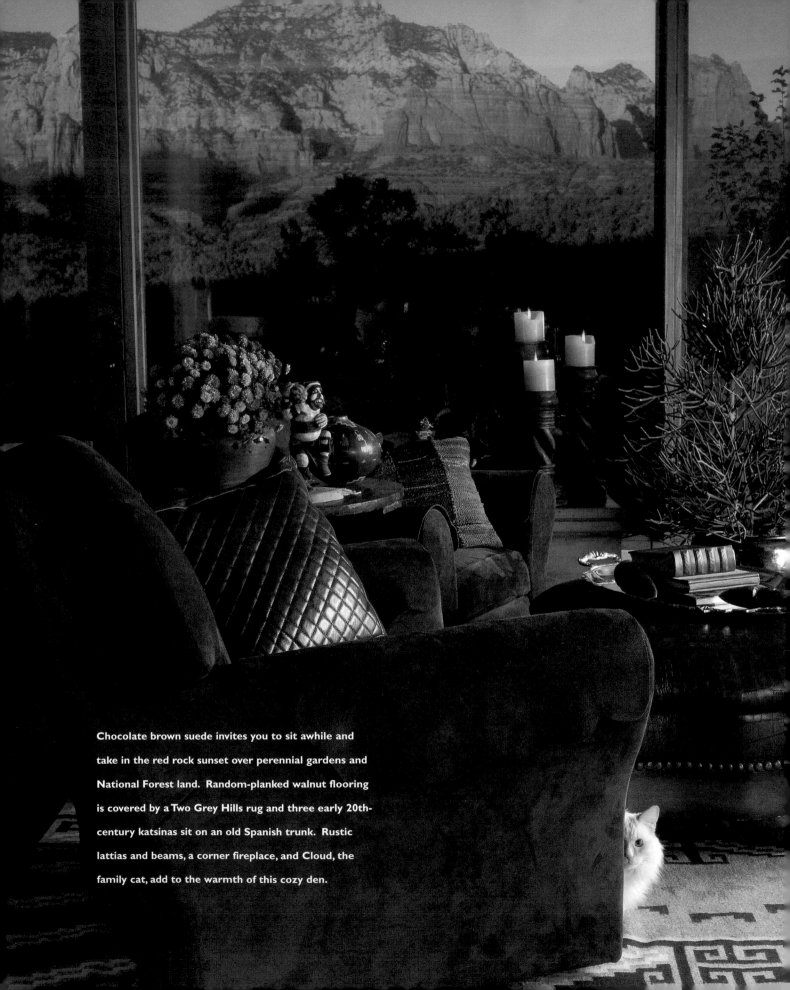

Chocolate brown suede invites you to sit awhile and
take in the red rock sunset over perennial gardens and
National Forest land. Random-planked walnut flooring
is covered by a Two Grey Hills rug and three early 20th-
century katsinas sit on an old Spanish trunk. Rustic
lattias and beams, a corner fireplace, and Cloud, the
family cat, add to the warmth of this cozy den.

contents

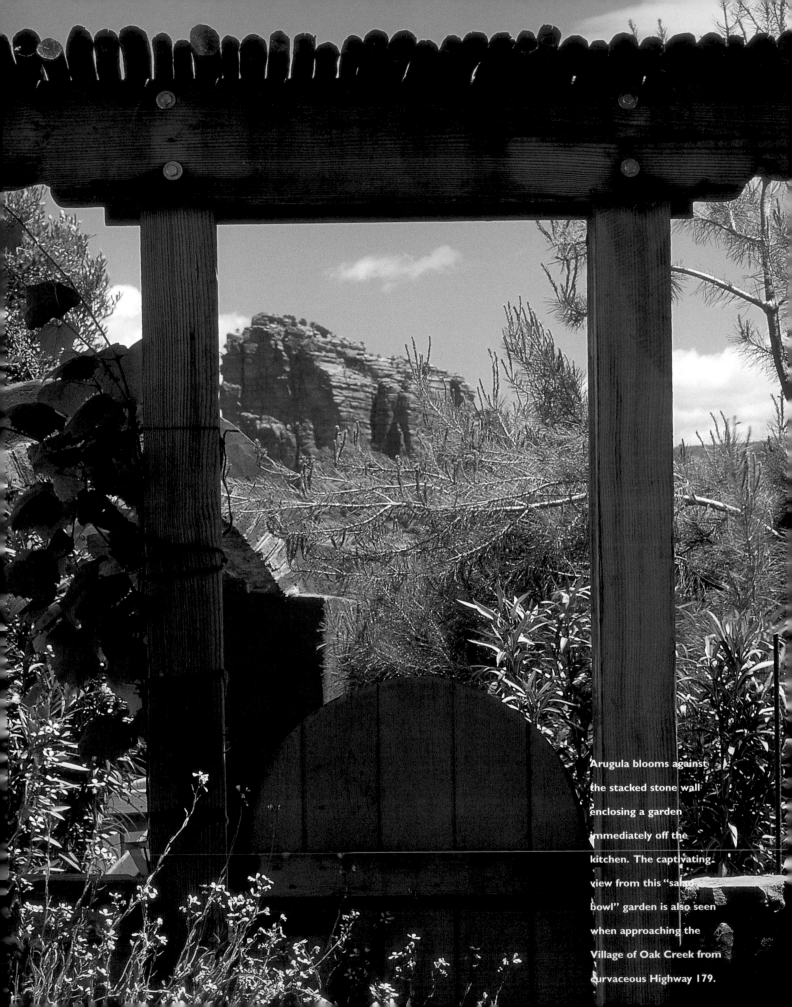

Arugula blooms against the stacked stone wall enclosing a garden immediately off the kitchen. The captivating view from this "salad bowl" garden is also seen when approaching the Village of Oak Creek from curvaceous Highway 179.

hen traveling to other places, we wonder what life is really like for the people who live there. What is behind the walls of their homes? How do they inhabit their environment? Did they choose to live there? Why? We imagined that some people coming to Sedona wondered the same things about our town. Several years ago, after meeting and becoming friends, we began to talk about creating a book through which we could share Sedona with you. It's been a wild journey, and not without setbacks! But we persevered, and eventually found the two missing links, our wonderful friends and partners Paula Jansen, who did the photography for this book, and Carol Haralson, who edited, designed, and produced it. The four of us have had a wondrous experience creating this book for you, each contributing in her own way to the whole.

In gathering the material for *A Window on Sedona,* we came up with our own definition of what the locals refer to as "red rock fever." This ailment is not to be confused with a physical disease. Instead, it's a strong emotional reaction brought on by a first glimpse of breath-taking red rock country. The symptoms include euphoria, fantasies of escape, new-found fascination with nature, and a peculiar attraction to real estate pamphlets. The fever is epidemic in our area.

Even old-time locals—as we one day will be—have frequent recurrences of red rock fever. We can be whisking eggs in the kitchen and with one glance out the window catch the light glowing on crimson cliffs, and are instantly mesmerized. Eggs forgotten, we are lost again in the moment and the beauty.

Our intention with this book is to weave you into the hearts and homes of Sedona. If you are a fellow resident, we celebrate our home with you. If you are not a resident, we want you to experience not only the grand vistas visible from your car or campsite, but also the ordinary lives of people living in an extraordinary place. You will peek into gardens, barns, kitchens, baths, bedrooms, and living rooms and observe unusual and delightful details of personal expression. We've even collected a group of recipes that we think capture the essence of cooking and dining amid the red rocks—and we invite you to savor them, putting Sedona on your table at home, wherever home may be, down the street or on the far side of the globe.

Whether you are a frequent or a first-time visitor, a current or future resident, an old-timer or a newcomer, we hope you will enjoy the journey.

Dottie Webster and Pamela Morris

ACKNOWLEDGMENTS

So much generosity has flowed toward us during the creation of this project. We are especially grateful to Ellen Rolfes and Tafi Cole; and to Kate Ruland-Thorne, Lynette Jennings, Annie Miller, Joanne Goldwater, Barbara Pool Fenzl, Adrienne Hanley, and Diane Papadakis. For allowing us to glimpse the private creative expression of their homes and lives, we are deeply indebted to Fuller Barnes, Vada and Dick Barstow, Sharon and Joe Beeler, Wendy Bialek and Jeff Burger, Bradshaw Ranch owners, Beverly and Lloyd Castleberry, Connie and Hugh Coble, Brian Dante, Mary and Gary Garland, Gloria Guadarrama, Adrienne and Edward Hanley, Sharon and Ollie Harper, Susan Kliewer and Jeff Dolan, Lucy and Pete Leach, Mary and Bob Longpre, Ludmila and Don Loisy, Lynn and Frank Matthews, Cindy and John McCain, Jackie and Bob McLean, Cheryl and Pete Merolo, Mary and Chuck Nyberg, Karin and Jim Offield, Karen Rambo and Hal Abbott, Nancy and Ed Santacruz, Robert Shields, Chris Spheeris, Sue and Jay Stuckey, Curt Walters, Karen and Shawn Wendell, and the members of our own households. Their windows on Sedona have helped to frame this portrait of a place.

For culinary contributions, we thank Connie Coble, Joanna Dean, Maria Delgado, John and Susan Ettlinger, Barbara Pool Fenzl, Carla Gasper, Joanne Goldwater, Gloria Guadarrama, Kurt Jacobsen, Karen Rambo, and Amanda Stine. For supplemental photographic images, we thank Bill Landing and Phil Morris.

To the kind friends who have listened and advised, and who have forgiven our absence during the creation of this book, we extend our deepest gratitude. And to the many souls throughout the red rock community whose goodwill has nurtured our progress, we say thank you.

Just as a window can never frame an entire view, a book like this cannot be comprehensive. The places and scenes we have included are of necessity an arbitrary representation. Sedona is rich in magical spots, creative people, and extraordinary dwellings both lavish and modest, and though we cannot name them all, we honor each of them.

Dottie Webster, Pamela Morris, Paula Jansen, and Carol Haralson

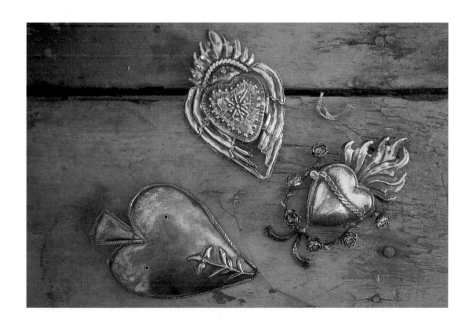

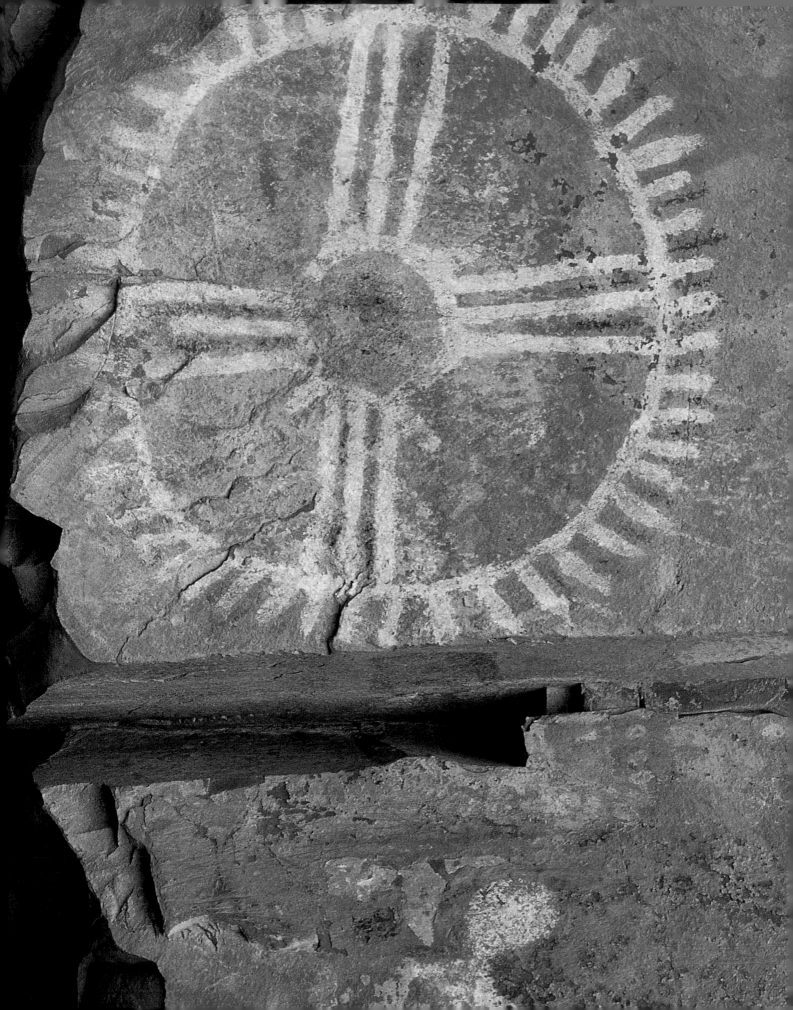

earth

The trail top is a high vantage point. We gazed for a long time at the vast land of rainbow rock confusion.

KENT FROST, MY CANYONLANDS

As you approach Sedona from the west along State Highway 179, you come to a bend in the road where suddenly the red rocks appear. The landscape changes so abruptly that you feel you could be looking at a surrealist painting or a Spielberg movie set. Tourists pull off the road and step from their cars, cameras in hand.

Early pioneers used these time-whittled configurations as landmarks, naming them for familiar shapes: Coffeepot, Steamboat, Camel Head, Bell Rock. These names, and more recent ones, are commonly used by locals. Planning a hike with friends, you might suggest, "Let's pack a lunch, meet up at Schnebly Hill, and hike Snoopy." Perhaps because the red rocks are so astonishing in size and shape, people have given them human scale by tying them to familiar names, which are woven into everyday speech and lore.

The coloration of the rocks is so stunning that at first you may miss other equally saturated colors in the visual environment, but soon you notice that the sculpted red forms rise against a profoundly cobalt sky scattered with perfectly white clouds, and dotting the bases of the red formations are green piñon pines and manzanita. To quote a local, "When we get back to Sedona after spending time away, it's as if we were traveling in a black-and-white world and have come home to Technicolor."

Our moderate, dry climate at 4,500-foot elevation produces both desert and mountain landscapes. Within a relatively small area you may see prickly pear cactus, ocotillo, and mesquite, all dwarfed by bristlecone pine and alligator juniper trees. Although much of the foliage is evergreen, there are plenty of deciduous varieties to yield a colorful fall display. One of the joys of springtime hiking is suddenly seeing a hedgehog cactus covered with fuschia blooms, or a rough century plant adorned with delicate yellow flowers. Century plants can grow up to a foot a day during their showtime, reaching upwards to a possible ten to twelve feet. Indian paintbrush, prickle poppy, black-eyed Susan, angelita daisies, and other wildflowers carpet the red earth, one continually replacing another as the year progresses.

The rocky canyons and mesas were home to Sinagua Indians hundreds of years ago. Ruins of their habitations still dot the Sedona locale and their rock

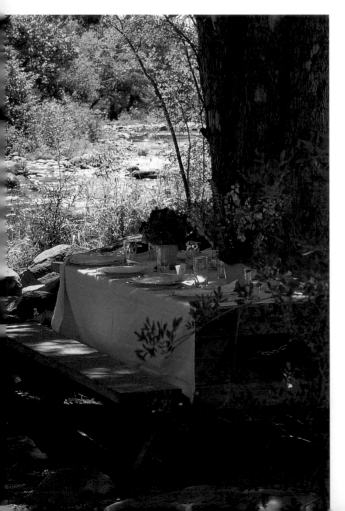

A picnic table is set for a romantic supper at the foot of a rolling lawn on the banks of Oak Creek. This location was the backdrop for a scene from the 1946 movie *Angel and the Badman,* starring John Wayne.

THE CANYON WE SO
ADMIRE IN ALL ITS
SUMMER GLORY IS EVEN
MORE INTENSE AND
SUBLIME IN THE LATE
AUTUMN GLOW.

ZANE GREY

Pascelli, Queen
Elizabeth, Tropicana, and
Oregold roses combine
with red rock
background drama to
create a scene of near
perfection.

drawings, or petroglyphs, provide us clues to their everyday lives. When hiking in some places, it is quite common to see scattered by the trail small broken pieces of prehistoric pottery still ornamented with cream and dove-gray designs. If you are really fortunate, you may find a polished stone point used by a long-ago hunter. Archaeological ethics and explorer's etiquette (and federal law, if you are on Forest Service land) demand that you leave these tokens where you found them, but for a moment you can stand in the Sonoran sunlight with eyes closed, holding the smooth shard of an ancient cooking pot or seed vessel, and hear the sounds of prehistoric village life, children calling out, dried corn grinding against a rough stone metate, fiber-sandaled feet moving over the dry earth. We don't know why the Sinaguans departed, though drought may have played a role. Other native groups arrived later with their own methods of farming, hunting, and trading. Later still, westward-moving pioneers paused here and realized the survival potential in the fertile soil along the creek beds. They homesteaded, planted fruit trees, and harvested vegetables. Their fields and orchards became the breadbasket for surrounding settlements.

Today we still cultivate our gardens and orchards. Flowering annuals and perennials, vegetables, and herbs grow abundantly in Sedona. A weekly farmer's market at Tlaquepaque during the warm months provides the venue for some locals to sell their produce. The aroma of freshly baked breads, bouquets of dewy flowers, and colorful displays of newly picked organic produce invite passersby to stop and buy.

A friend from the Midwest told us she could not live in Sedona because she would so miss her beloved roses. But roses flourish here from April till December. As with the unique blend of old-time locals and new arrivals, Sedona gardens are home to beavertail cactus, rabbitbrush, and four-winged saltbush, all thriving side by side with old English roses and modern hybrids, pansies, poppies, and primroses. Hollyhocks sway against adobe

walls and sunflowers stand tall along many unpaved roadsides. Xeriscaping is a way of life for the ecologically conscious gardener, while other greenthumbs still prefer lawns and lush flower beds. Even at the height of summer, mornings and evenings are cool, and in winter the occasional snowfall melts by noon in the high-desert sun.

Wildlife continues to share this pleasant habitat. Coyotes chase jackrabbits across open landscape and pierce the evening air with their cacaphonous howls. Families of javelina show up for a buffet of spring bulbs or root under the bird feeders for a seedy snack. Ravens roost in the low washes, and deer, fox, and bobcats share the piñon-and-juniper forest that surrounds much of the town. Even an occasional mountain lion may be spotted in the area, perhaps on a backyard *chaise longue*. One night a friend entering her bedroom heard a scraping sound. Heart pounding, she switched on a light and saw a black bear through the sliding door. Rattlesnakes may appear on doorsteps and queues of egg-sized Gambel's quail stream along behind their portly mothers down garden paths. Cattle grazing on the land and cowpokes on horseback, remnants of the Old West, are still part of Sedona life, too. Coexistence is possible in this ample place.

Maintaining a balance between nature and the impact of human development on Sedona is a constant internal and external battle. The balance is made somewhat easier by bountiful parcels of National Forest land that both surround the town and are an integrated part of it. Because of this, we can take comfort that the red rocks will be preserved. However, the pressure of increasing population and the related demand for holiday real estate, cleared homesites, paved roads, and water will continue to present issues that must be wisely decided in order to preserve this fragile area that is one of the most unique places on earth.

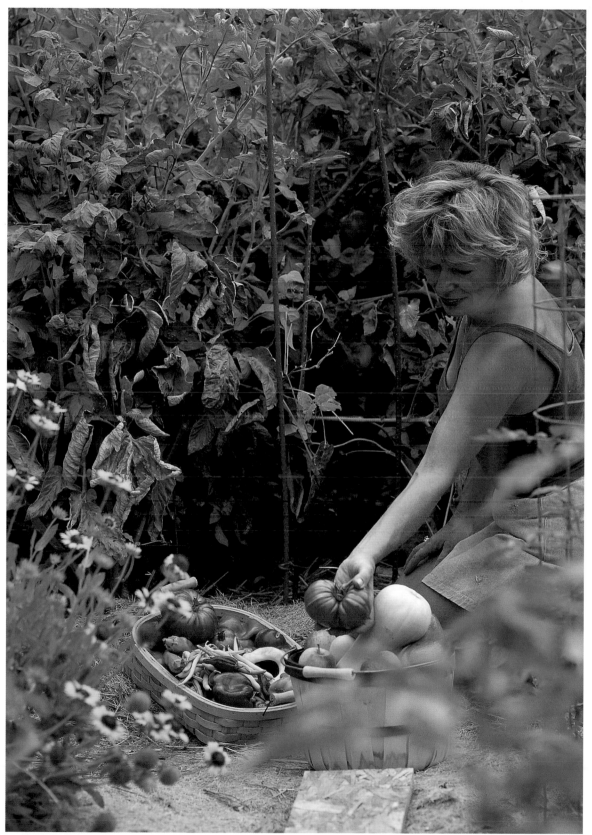

Ludmila Loisy has a national reputation for her ability to produce healthy, abundant vegetables and fruits using innovative growing techniques. She fled her native Czechoslovakia many years ago during a time of political upheaval and now enjoys a peaceful life with her husband Don in Sedona.

THE BEAUTY OF GREEN FOLIAGE

AND AMBER STREAM AND BROWN

TREE TRUNKS AND GREY ROCKS AND

RED WALLS WAS THERE . . .

Zane Grey

Eagle Mountain Ranch, an original homestead first settled in 1875, includes a long stretch of Oak Creek that allowed for the production of apples and the raising of cattle.

The building at right was constructed in 1880 from materials gathered on site using the stacked rock method. The photo above is a detail of a later building, erected in the early 1900s. Its rock wall was cemented with mortar. Both were used as apple storage sheds and remain now as historical reminders of the pioneer days.

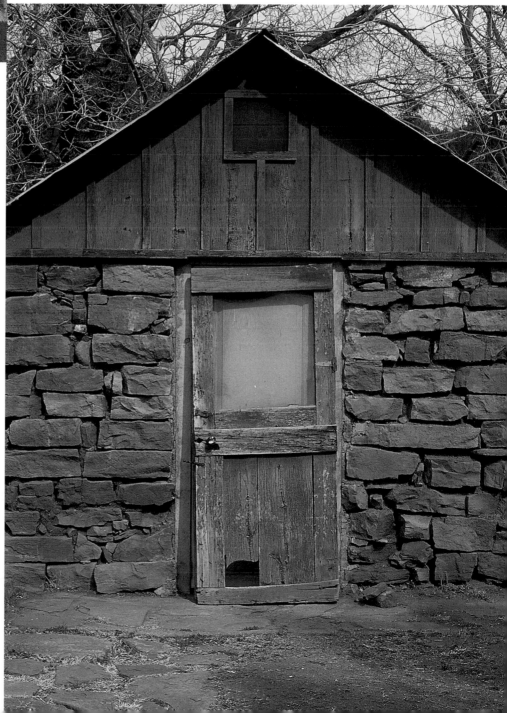

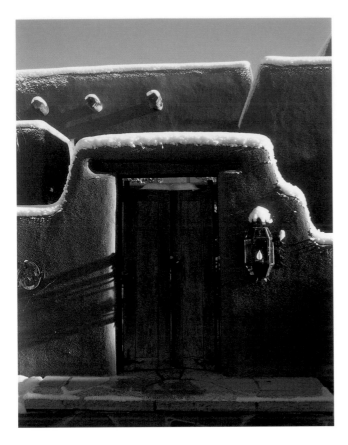

A rare winter snow transforms the home into a gingerbread castle. Antique painted Mexican doors, with hinges crafted by Mark Finn, a Sedona blacksmith, open onto a summer breakfast patio leading into the kitchen. The hand-crafted tin wall sconce was made by a southern Arizona artist.

Nestled into the forest overlooking Soldiers Pass Vista is a home fashioned after the ancient Taos Pueblo style using adobe mud blocks. The structure is finished with a contemporary version of plaster, providing surface stability and solid insulation from sound and outside temperatures. Living within these walls, the owners feel "a sense of being cocooned in the earth, of harmony, peace, and balance, along with a connection to the past."

SNOWSTORMS ARE FOLLOWED BY A PEACEFUL HUSH.

TREES STAND BLANKETED AND MOTIONLESS. . .

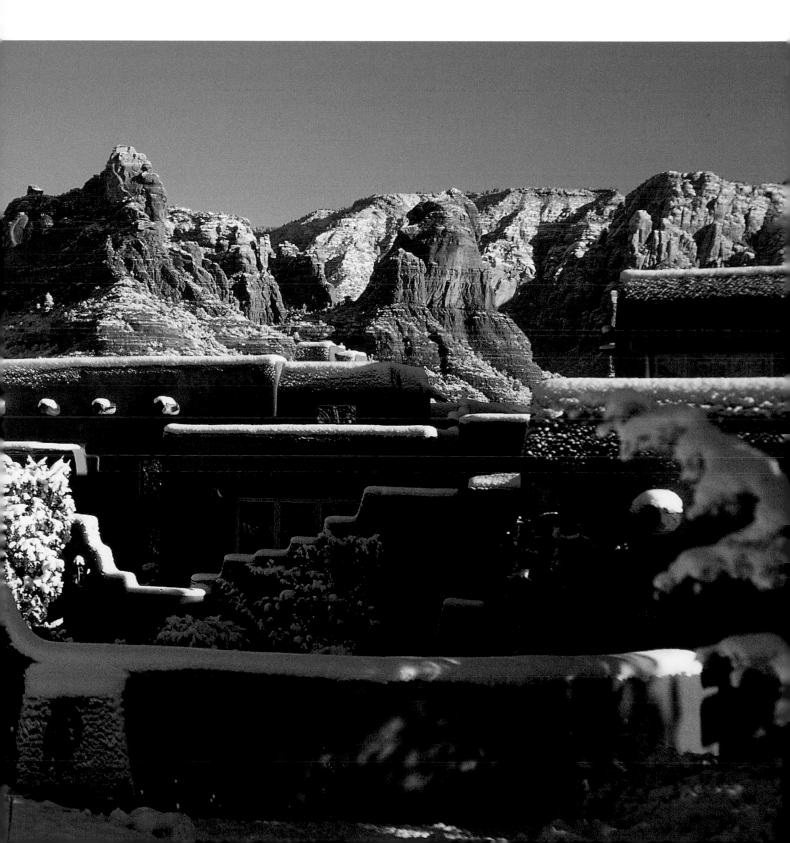

light

I know not a single word fine enough for light . . . holy, beamless, bodiless, inaudible floods of light.

JOHN MUIR

Sedona's scenery is bathed in a brilliant mosaic of colorful light which constantly changes according to season, weather, and time of day. A sudden astounding image of the red rocks basted in light makes you want to hit the pause button, but in a fleeting moment it disappears before your eyes, to be replaced by a different, and riveting, luminous spectacle. A frequent sight for locals driving routinely around town is that of tourists leaning from their stopped cars to snap a "Kodak moment." Glancing in the rear view mirror, the same locals may quickly apply their own brakes and stop to join in watching a particularly amazing act in nature's light and shadow show.

The first dim light of daybreak, blissfully silent, is quickly followed by a multitude of birds announcing the sun's luminescent arrival behind the jagged silhouettes of the red rocks. As the day blooms in this western high country, the light intensifies quickly. Protection from ultraviolet rays requires constant awareness of the need for sunblock, dark glasses, and brimmed hats.

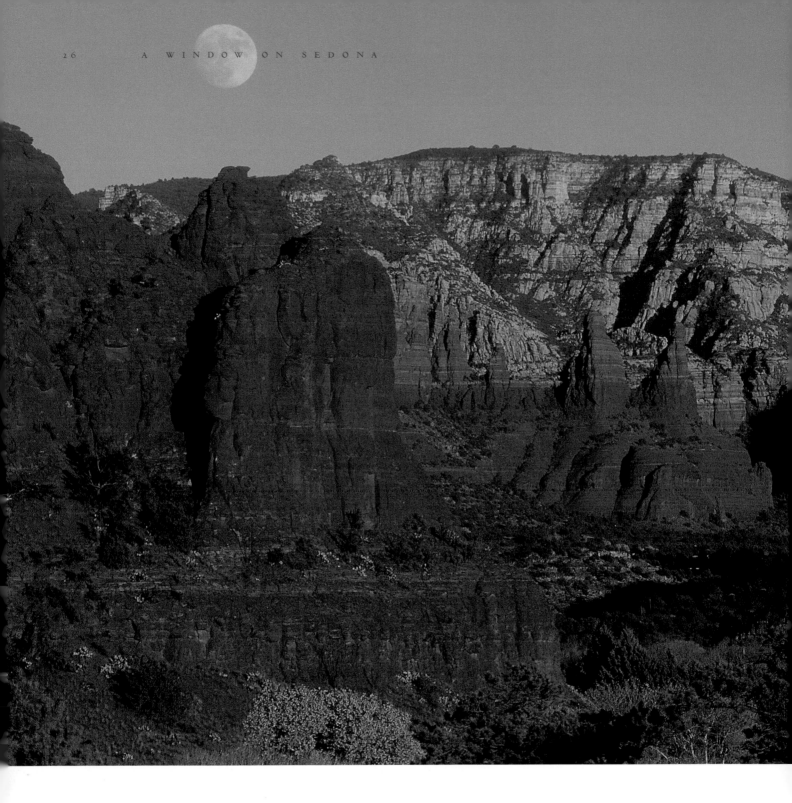

"THIS IS ONE OF THE BIG ROUND RIPE DAYS THAT

SO FATTENED OUR LIVES—SO MUCH OF SUN ON ONE

SIDE, SO MUCH OF MOON ON THE OTHER."

John Muir

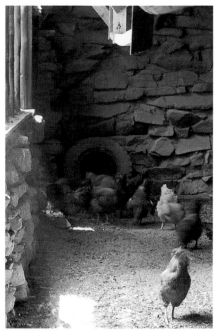

When hiking along the canyons, you see shafts of sunlight piercing through the pines to dapple the path with tinges of color and turn plant leaves incandescent. Prisms of light reflecting off fountains, pools, and the creek's surface give the apparition of sparkling diamonds.

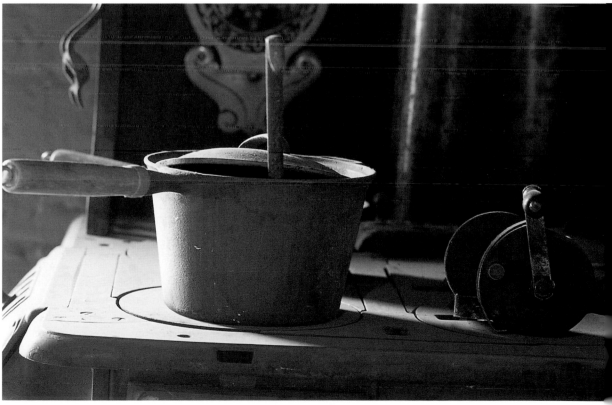

Chickens partying in their coop are sheltered from the noonday sun; and an old western cookstove and stewpot catch the early morning light at Bradshaw Ranch.

In the heat of summer, radiant midday light makes shade a welcome shelter, while in winter the same sunlight is a welcome embrace. An occasional cloudy day can be a respite from the sunshine, though after three such days in a row the fairweather locals—addicted to Sedona's characteristic light—may grow testy.

Late summer monsoon rains bring an amazing light show in the sky. Lightning flashes over the red rocks and ignites them with a doubly fiery hue. Dark cloud formations alternate with sunbreaks, instantly changing the array of colors in the chiseled faces of rocky cliffs. The rare blanket of snow in winter is welcomed for its pure glistening contrast with the red rock and earth as well as for its life-giving moisture. Sometimes the nearby peaks are dusted with snow as if with a sifting of powdered sugar.

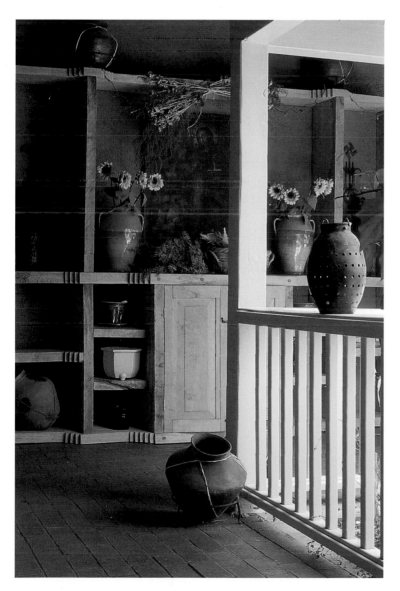

Light plays on a rustic box-elder cupboard, designed and built by Ed Wade and Carl Brune. The portale of the house wraps around an intimate central courtyard. All the rooms open separately onto this space, here filled with morning light.

The wooded areas between Sedona and Flagstaff climb 3,000 feet up through a series of eco-niches, each with its own characteristic vegetation.

Many years ago in Indiana, the owners of this home mysteriously received an issue of *Arizona Highways* containing hauntingly beautiful photographs of Sedona, a place they had never seen. They were compelled to visit. They arrived, bought a patio home for occasional visits, and purchased their retirement property. During their transition years, they studied the design of traditional pueblo dwellings and decided to build in adobe. Today their dream home is a reality.

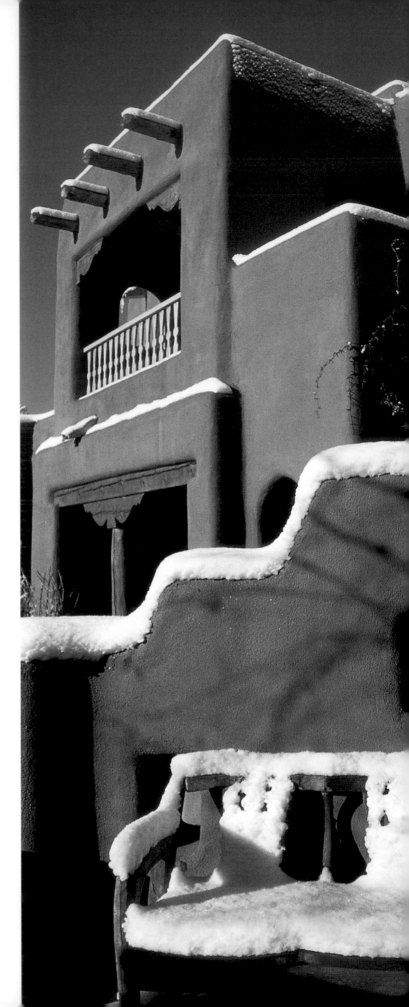

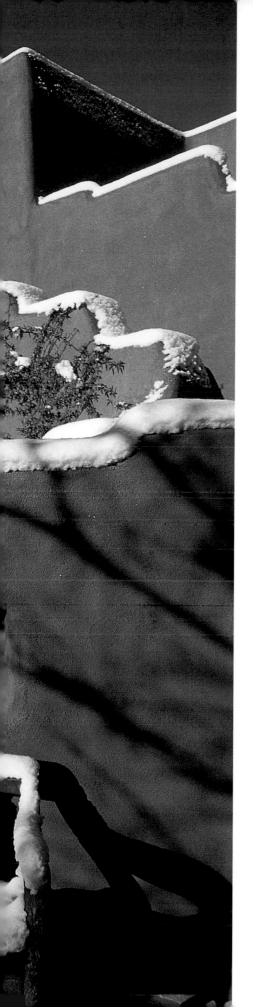

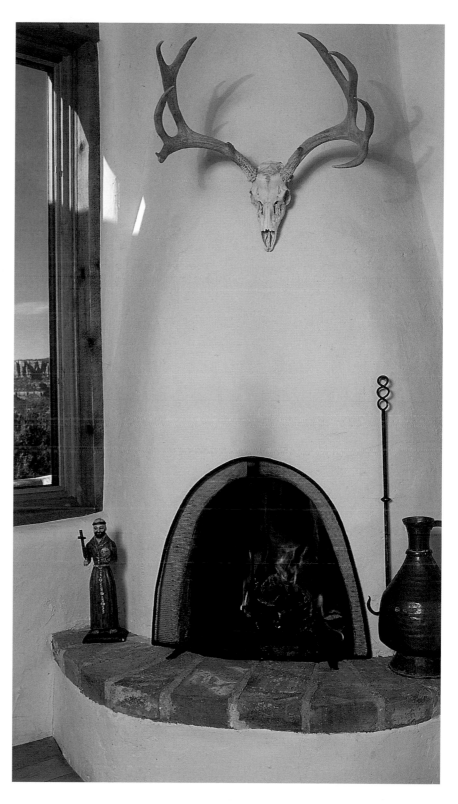

The Matthews family relocated from Colorado to Sedona where they
built a Spanish-inspired home. Here rays of warm sunlight beam onto
their traditional beehive fireplace glowing with its own heat.

Sunsets in Sedona are held in reverence. The Technicolor pageants occur daily, varying only in their timing. Tints of pink, orange, yellow, mauve, blue, purple, and red reflected in the sky cause the sidelit rocky silhouettes to deepen in color and to glow radiantly as the sun goes down like a fireball in the sky. When clouds are present, the phenomenon intensifies.

Understanding the presence of light in the pure, clear, dry air of the high Sonoran desert also means understanding its absence. Nights without moonlight are studded with stars. Seeing the full moon crest over the backlit outline of the red rocks is a mesmerizing experience. The moon overhead appears bright and huge as a searchlight, making every twig and pebble visible. Restrictions on the use of manmade outdoor lights at night help to preserve the intensity of these spectacles.

The light of Sedona brings us new awareness, bathing us continually with its ever-changing grand impression, and making us continually grateful.

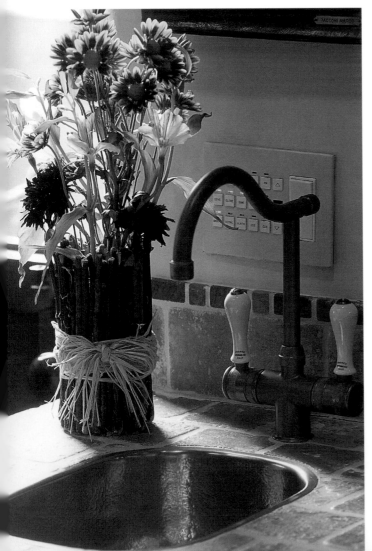

An open Dutch door welcomes fleeting afternoon light reflected on a hammered copper sink with antiqued faucet. Both are set in tumbled marble. A locally crafted twig vase is tied with raffia and filled with Gaillardia daisies from the owner's garden.

This light-filled room overlooking Oak Creek invites a relaxing soak while gazing at red rock scenery. Creamy white bead board trim is surrounded by marble reflecting the natural colors of the creekside boulders. The owner's collection of heart-shaped soaps adds to the romance of the room.

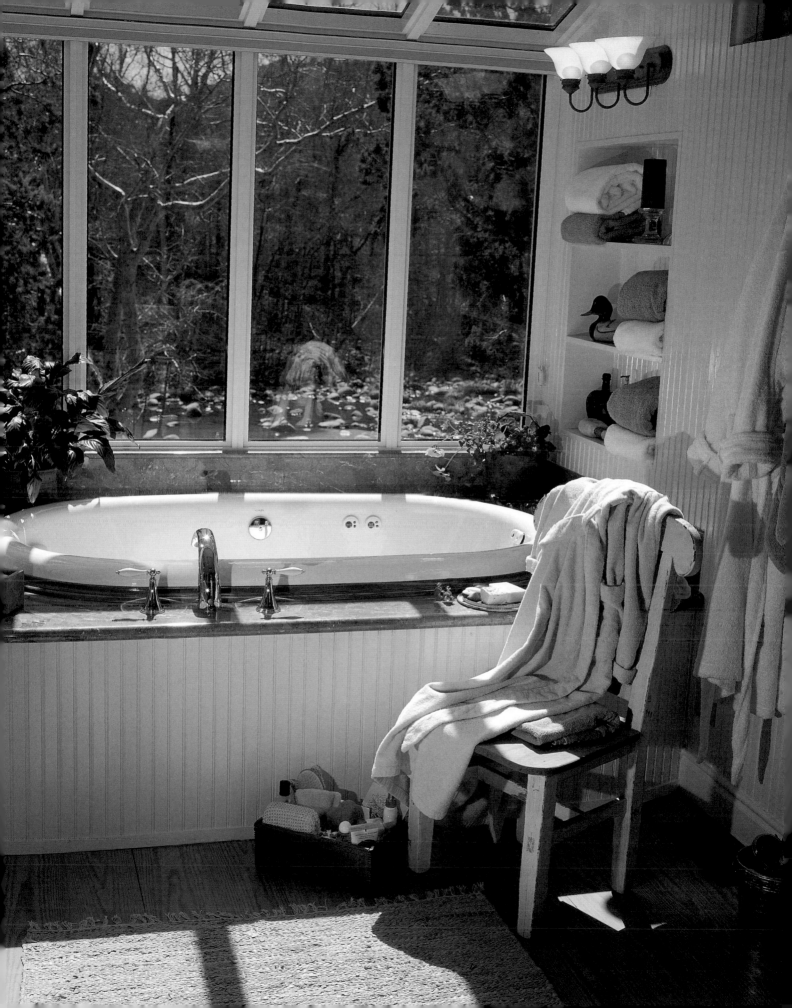

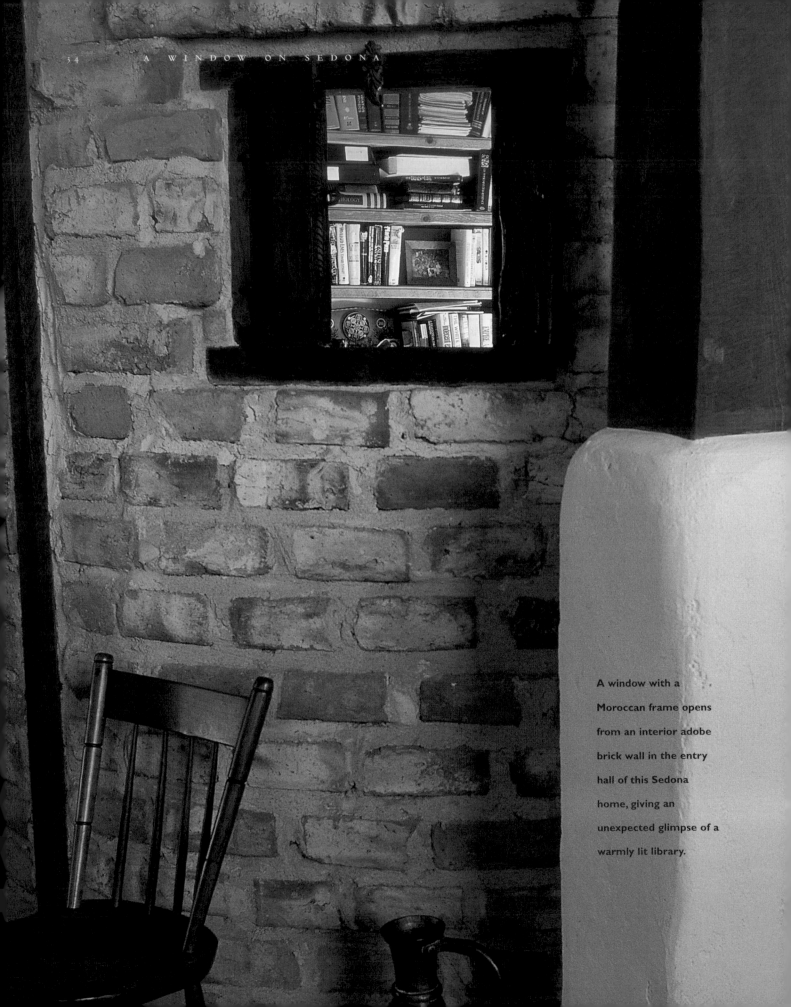

A window with a
Moroccan frame opens
from an interior adobe
brick wall in the entry
hall of this Sedona
home, giving an
unexpected glimpse of a
warmly lit library.

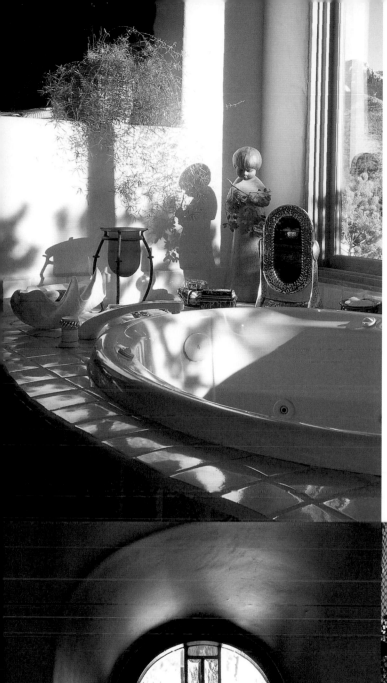

Three very different windows: A bathtub is a catch-basin for sunshine; an entryway window in a thick adobe wall filters Southwestern light through the ancient richness of stained glass; lace curtains frame a red rock view.

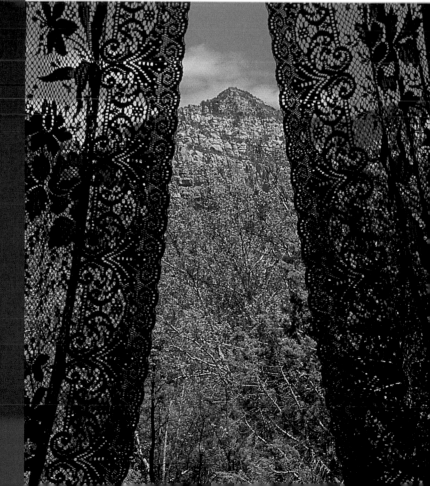

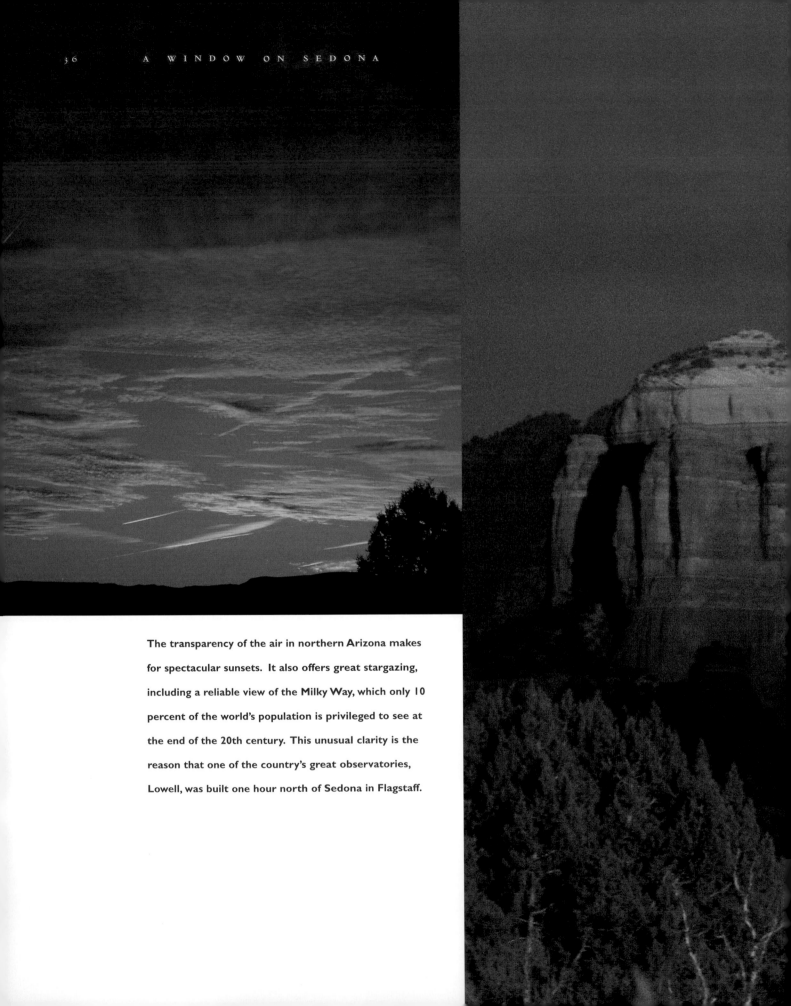

The transparency of the air in northern Arizona makes
for spectacular sunsets. It also offers great stargazing,
including a reliable view of the Milky Way, which only 10
percent of the world's population is privileged to see at
the end of the 20th century. This unusual clarity is the
reason that one of the country's great observatories,
Lowell, was built one hour north of Sedona in Flagstaff.

IT SEEMS TO BE NOT CLOTHED WITH
LIGHT, BUT WHOLLY COMPOSED OF IT,
LIKE THE WALL OF SOME CELESTIAL
CITY.

John Muir

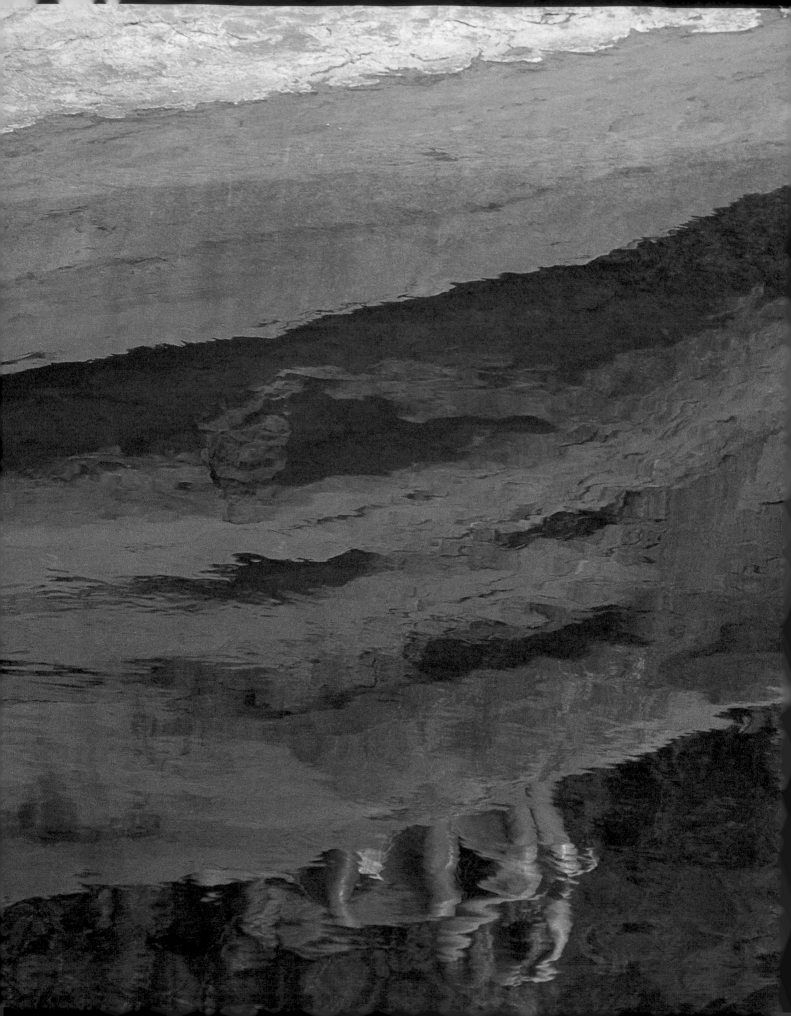

water

Under the blaze of the Sedona sun, clouds build,

while the red rocks seem to dream and wait for the

moisture to arrive.

The Indian community that once lived in what are now the ruins of Palatki
depended on the natural watershed and the life-giving fluid that collected
in catch-basins. We are fortunate today to access the underground aquifer
where water accumulates between the layers of rock formations. A suffi-
cient water table has allowed the human community to flourish here.
Imagine the pioneers coming upon Oak Creek and realizing they could survive in this
beautiful place. Discovering unclaimed land, they took squatters' rights, patented their
parcels, and implemented the Homestead Act for legal claim. They dug irrigation ditches,
built wooden troughs, and literally pulled the water onto the land for farming.

"Water witching" and good luck allowed other pioneers to tap into the precious under-ground liquid resource they needed to survive on property further from the creek. Using wooden buckets, they hauled water from their hand-dug and hand-pumped wells. The weathered remains of these life-sustaining structures recall to mind what a frontier luxury they were to the settlers. The land here is rocky. Today's prospective settlers who plan to build where there is no sewer service must build self-contained septic systems, and parcels must be assessed for rate of percolation—"perc tested"—before building can begin.

Set in the midst of red rock cliffs, cattle and sheep ranches sprung up in the bigness of the West. Ranchers built stock tanks, water wheels, and windmills for maintaining their herds while hired cowboys rode the fences, fought rustlers, and defended the boss's water rights.

G. W. Jordan, one of the original pioneers, dug a well and launched the Sedona Water System, later known as the Arizona Water Company. The community is still dependent on this distribution of well water. Original land grants containing legal rights to privately owned irrigation ditches and wells are now shared by many homeowner associations, subdi-visions, and neighborhoods. In Sedona, which incorporated only in 1988, water issues have surfaced as a major topic of controversy. Concerns about the potential pollution of Oak Creek brought about the development of a new city sewer system. The gray water it pro-duces is used for irrigation.

In winter, a heavy runoff from northern Arizona's snowpack melting into Oak Creek can cause flooding. In the monsoon season of late summer, skies open to spill sheets of rain that within minutes can change Oak Creek from a peaceful waterway into a swollen, roaring torrent. As it abates, the turbid water is red and opaque. "The ducks are floating in tomato soup today," say the creekside residents to their children.

Dry arroyos, or washes, can quickly fill with water during a sudden rain and are best avoided when storms are forecast. The glorious side of these periods of turbulent weather—besides the blessed moisture they bring to the land—is their spectacular beauty. Viewing nature's light show from a back portale while listening to thunder echo through the canyons of wet cinnamon-colored rock is more poignant than sitting in the grandstands at a fireworks display. Add a stray shaft of sunshine and a double rainbow and you may well become a believer in nature's perfection. Sedona is washed anew.

A water wheel was once a necessity in Sedona. This one remains as a nearly invisible relic on Ranger Road in the center of town, at the site of Sedona's first grocery market.

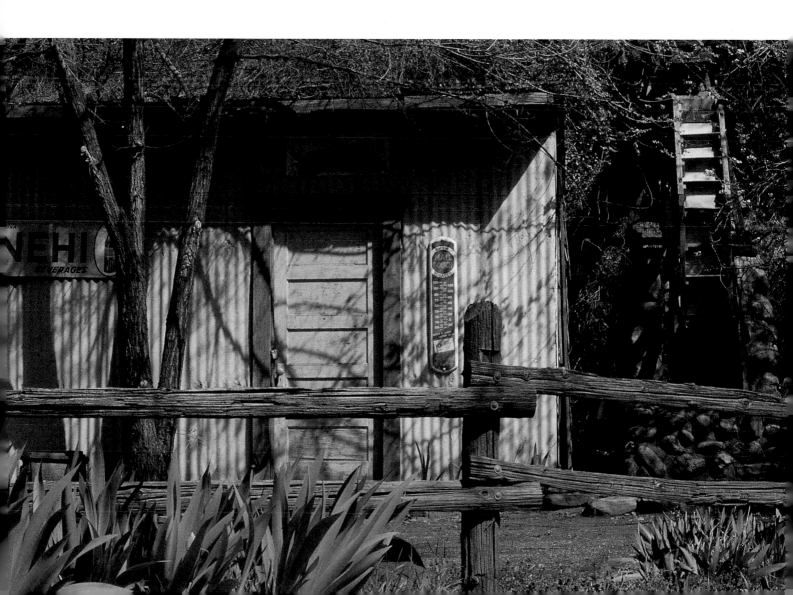

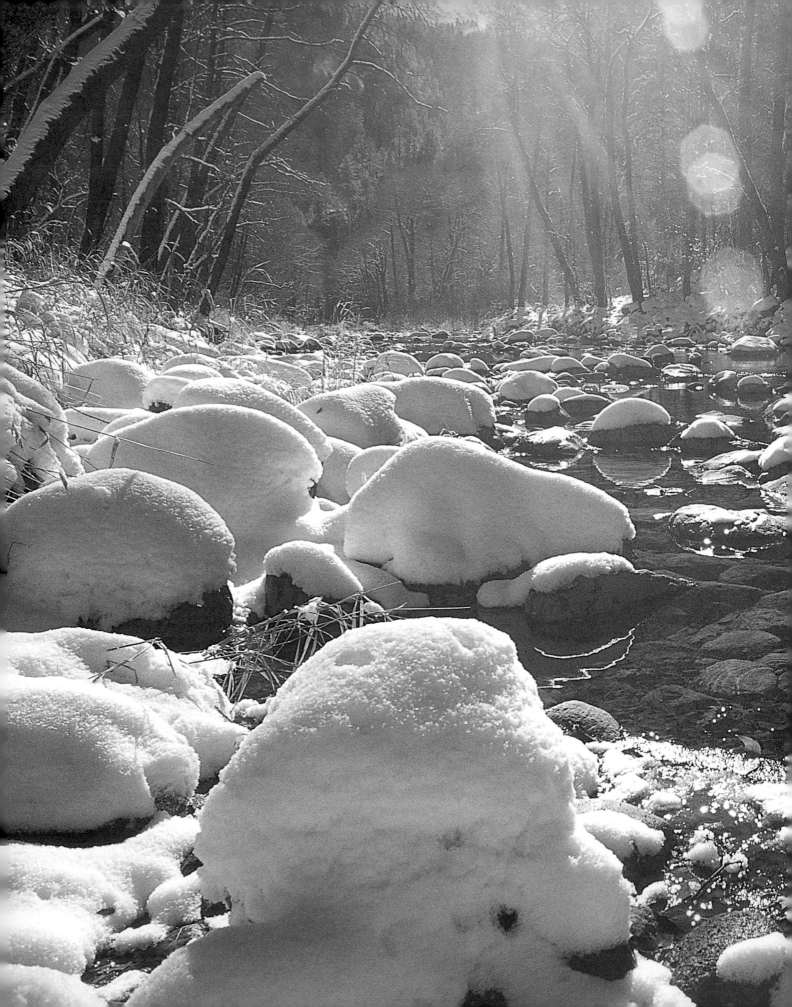

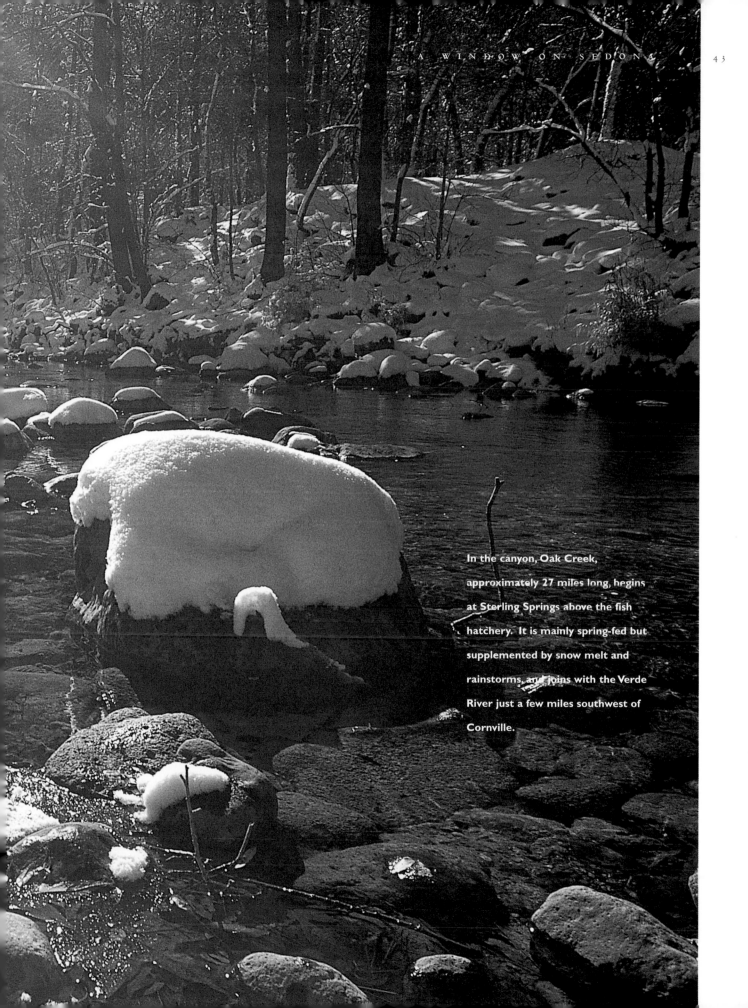

In the canyon, Oak Creek,
approximately 27 miles long, begins
at Sterling Springs above the fish
hatchery. It is mainly spring-fed but
supplemented by snow melt and
rainstorms, and joins with the Verde
River just a few miles southwest of
Cornville.

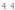

**A hardy lily (Chromatella) displays its delicate
beauty in the center of a still pond.**

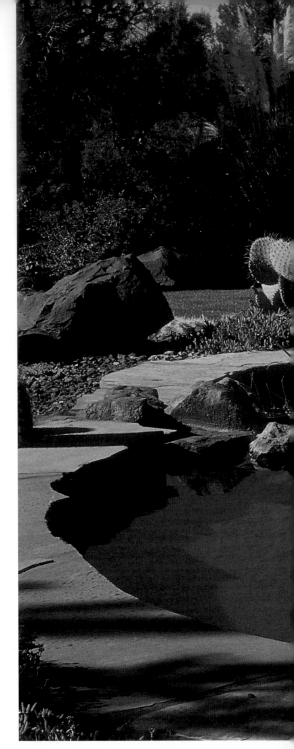

Oak Creek has been enjoyed by generations of fami-
lies in search of the perfect country setting for camping,
fly fishing, and picnicking. Taking the wild natural water
ride at Slide Rock on a hot summer day is memorable, as
is the proud smile on the face of a five-year-old holding
up his first prized fish at the local trout farm. Two natu-
ral springs, once visited by canyon pioneers with wooden
buckets, now yield delicious water for hikers with plastic water bottles. One enterprising
company taps this source for a bottled water that may be found a time zone or two east of
Sedona's clear creek.

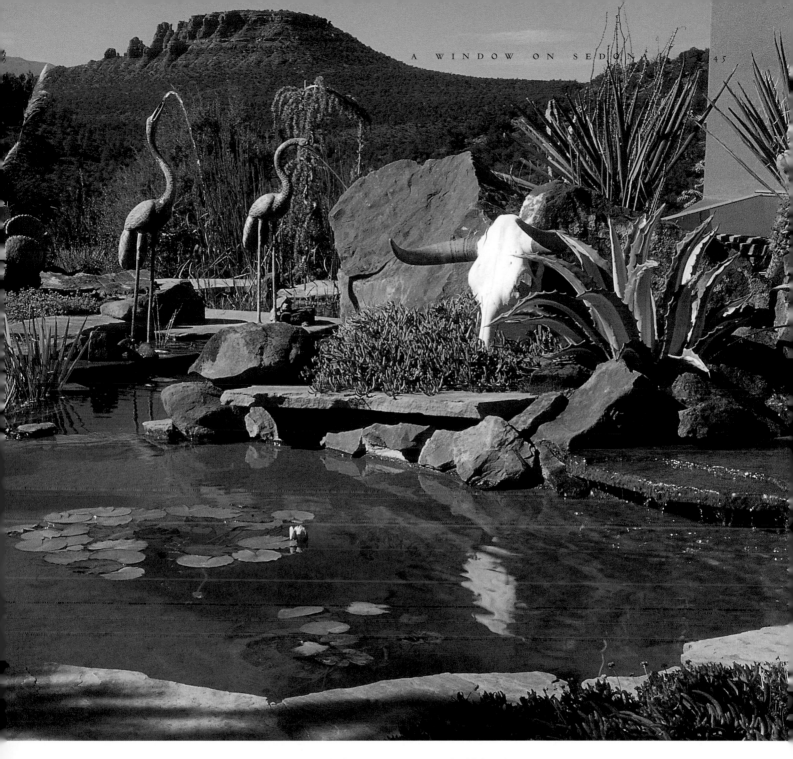

The contemporary home of the Merolo family features an entry pond with hand-
forged metal cranes, a cow skull, cactus, and lilies. The backdrop for this cool, watery
vision is a hot-colored ridge of dry red rock "natural sculpture."

At a number of Sedona's homes and resorts, the onetime luxury of the cowboy's Saturday night bath has been replaced by a stargazing soak in the outdoor hot tub. Water splashes in small fountains, and well-cherished pools and ponds mirror the red rocks tranquilly. Homes along grassy, tree-lined Oak Creek are scarce and treasured. Their fortunate owners enjoy a peaceful coexistence with the ducks, herons, eagles, and other wildlife drawn to the water.

Oak Creek was once the fruit basket for higher and colder communities with shorter growing seasons. At Garland's Lodge, Rob Lautze tends an organic apple orchard and Mario Valeruz nurtures a spectacular vegetable garden. The Garland family's inn retains its original creek water rights, so that it can irrigate this Eden naturally, from the creek below.

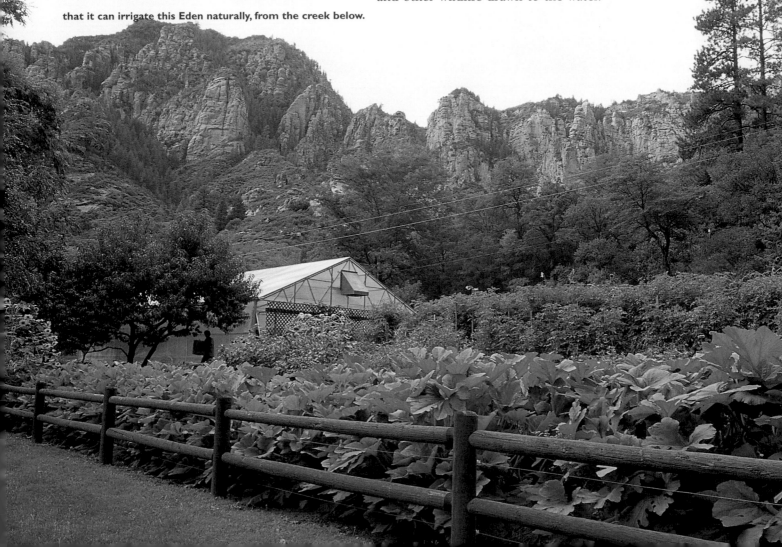

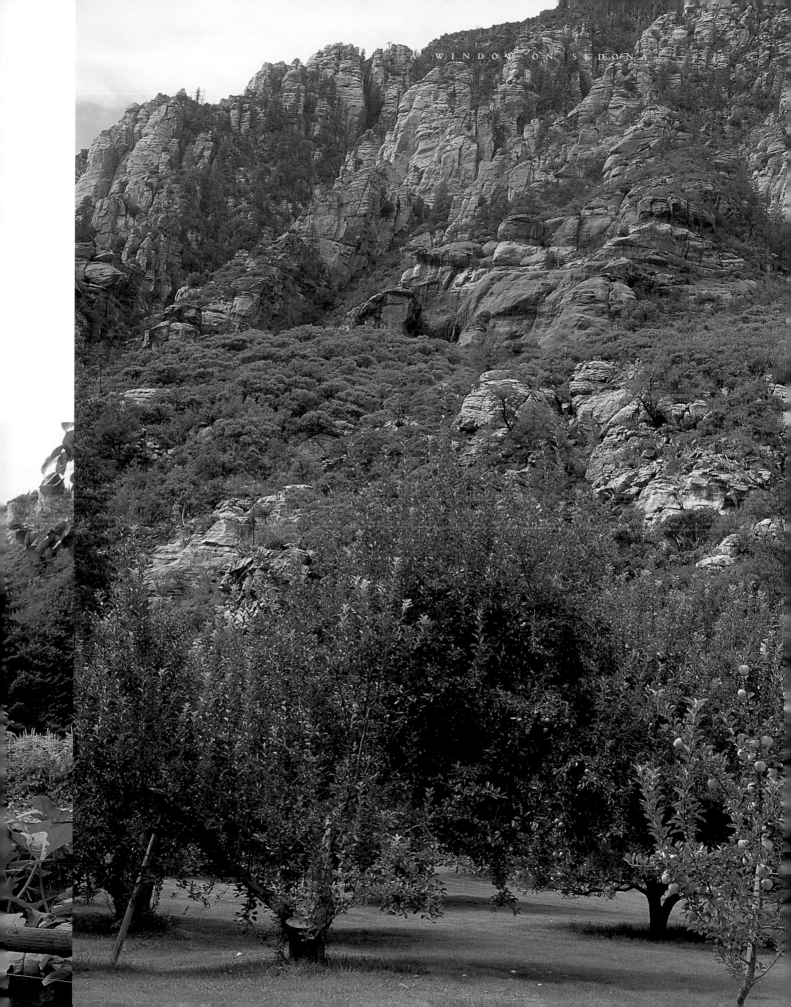

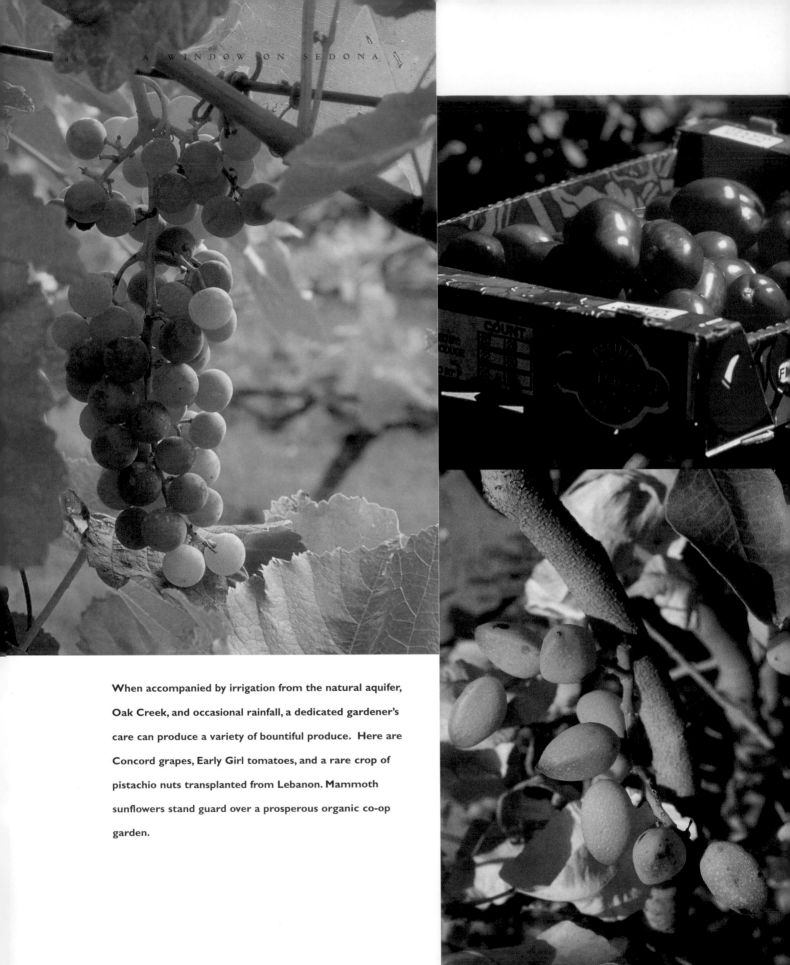

When accompanied by irrigation from the natural aquifer, Oak Creek, and occasional rainfall, a dedicated gardener's care can produce a variety of bountiful produce. Here are Concord grapes, Early Girl tomatoes, and a rare crop of pistachio nuts transplanted from Lebanon. Mammoth sunflowers stand guard over a prosperous organic co-op garden.

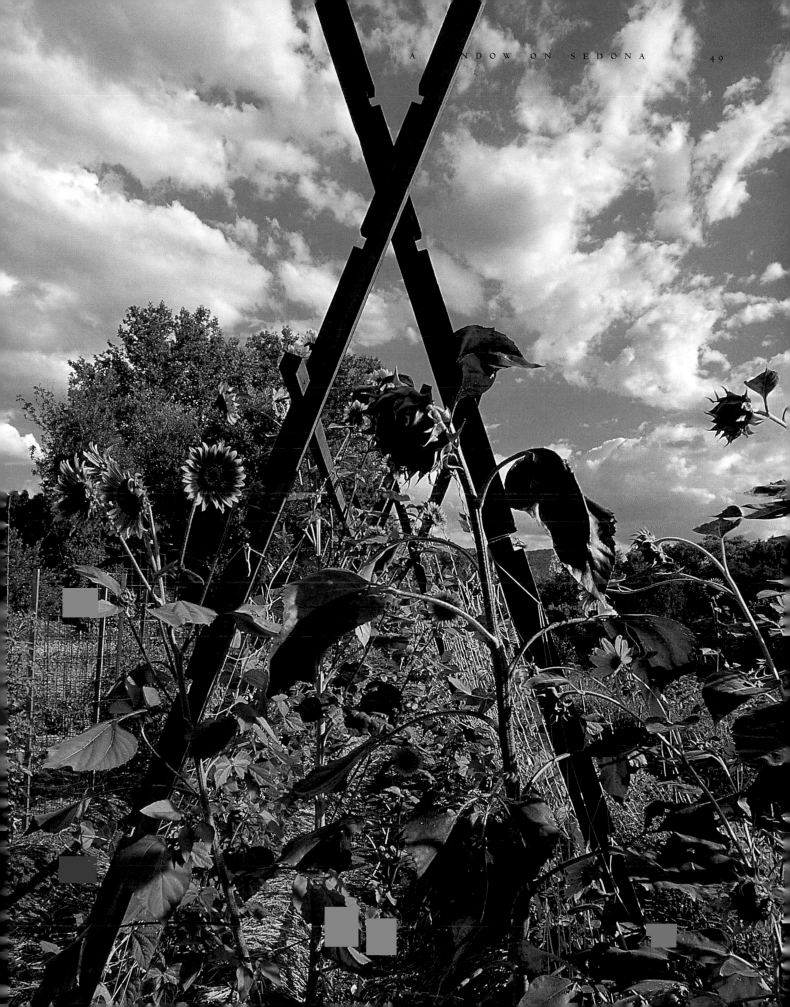

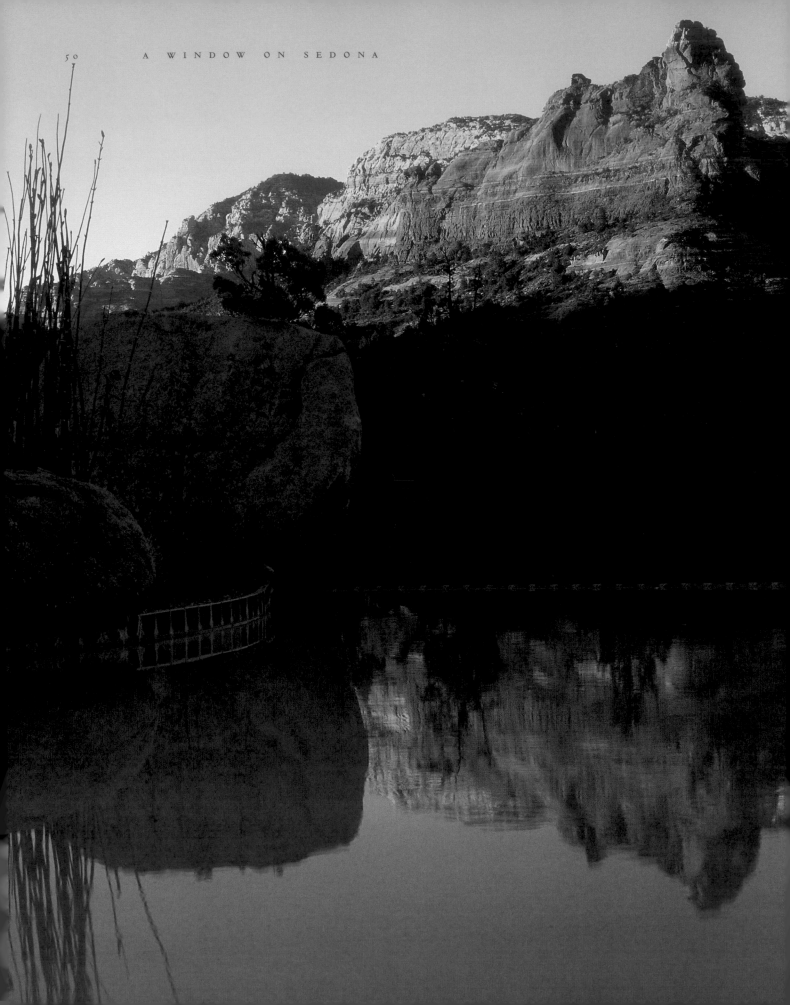

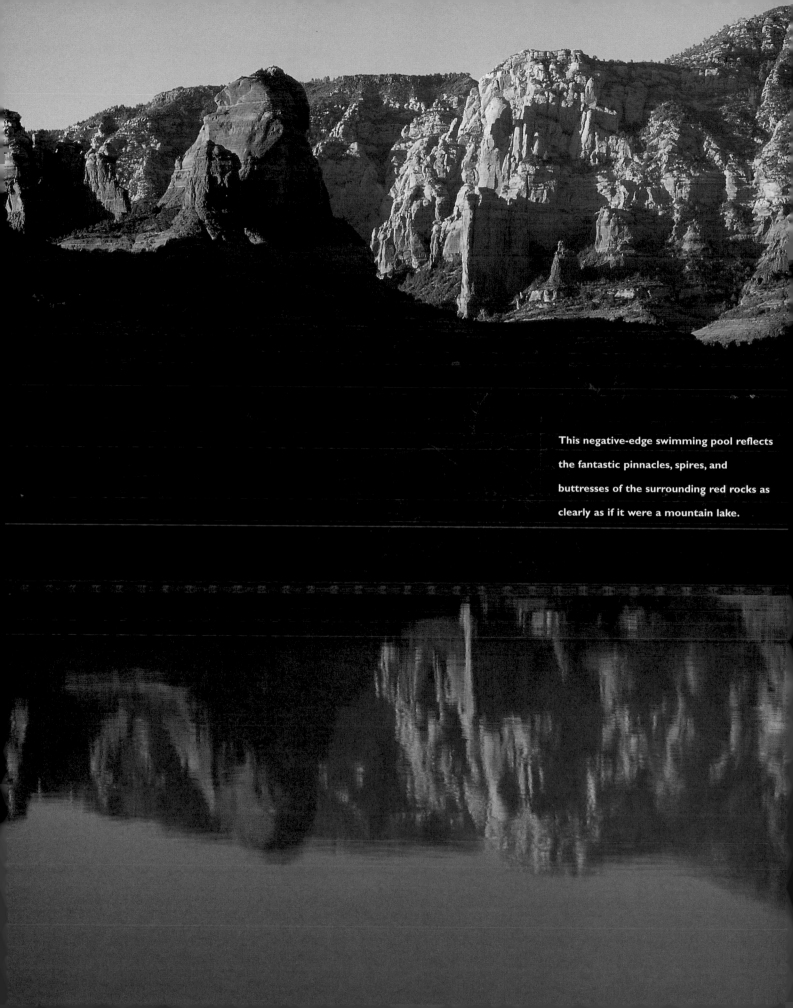

This negative-edge swimming pool reflects the fantastic pinnacles, spires, and buttresses of the surrounding red rocks as clearly as if it were a mountain lake.

Old-time desert dwellers, both prehistoric Native groups and later settlers, knew that the value of water in a dry land cannot be overstated. Contemporary residents have gradually become more and more conscious of the fragility of our water sources, and habits of conservation have become more widespread. We can only hope that this consciousness will develop and deepen, so that the residents and visitors who love this place will be part of its preservation, not its impoverishment.

A sculpted lion leans over a pond as if pausing for a drink in the courtyard garden of the Coble's Southwest designed home. The cool, soothing sound of water greets desert guests with oasis refreshment. "Coming home is like a lullaby," says Connie Coble. "Tranquil evening strolls along our walking path are interrupted only by the resident elk."

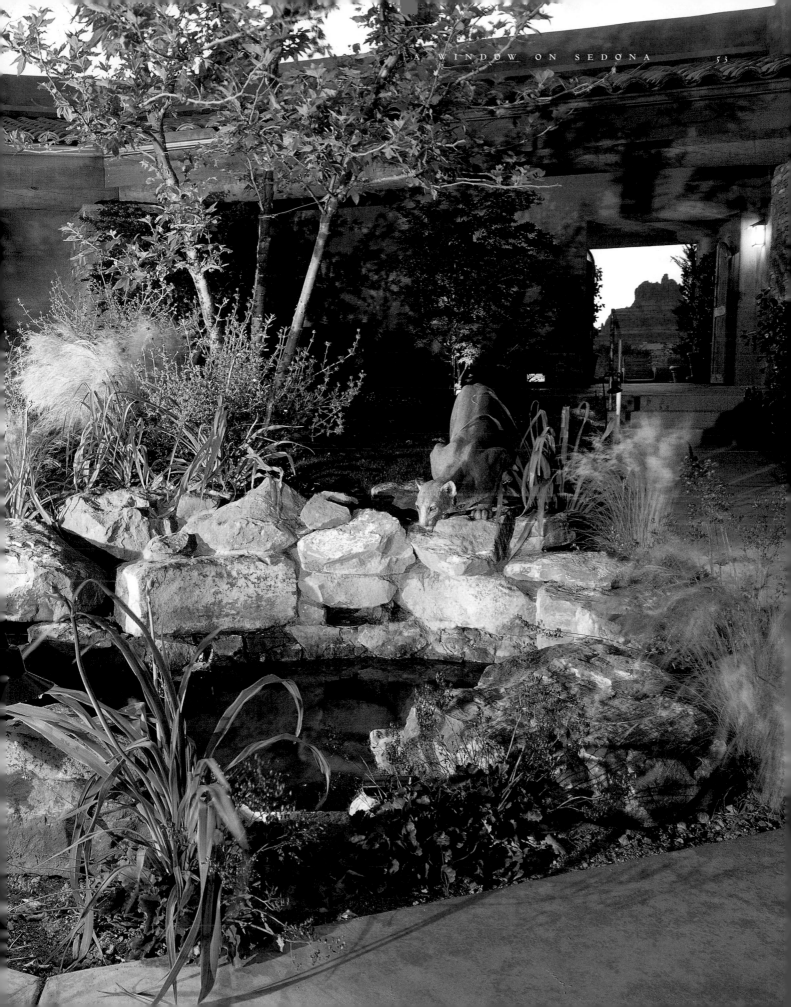

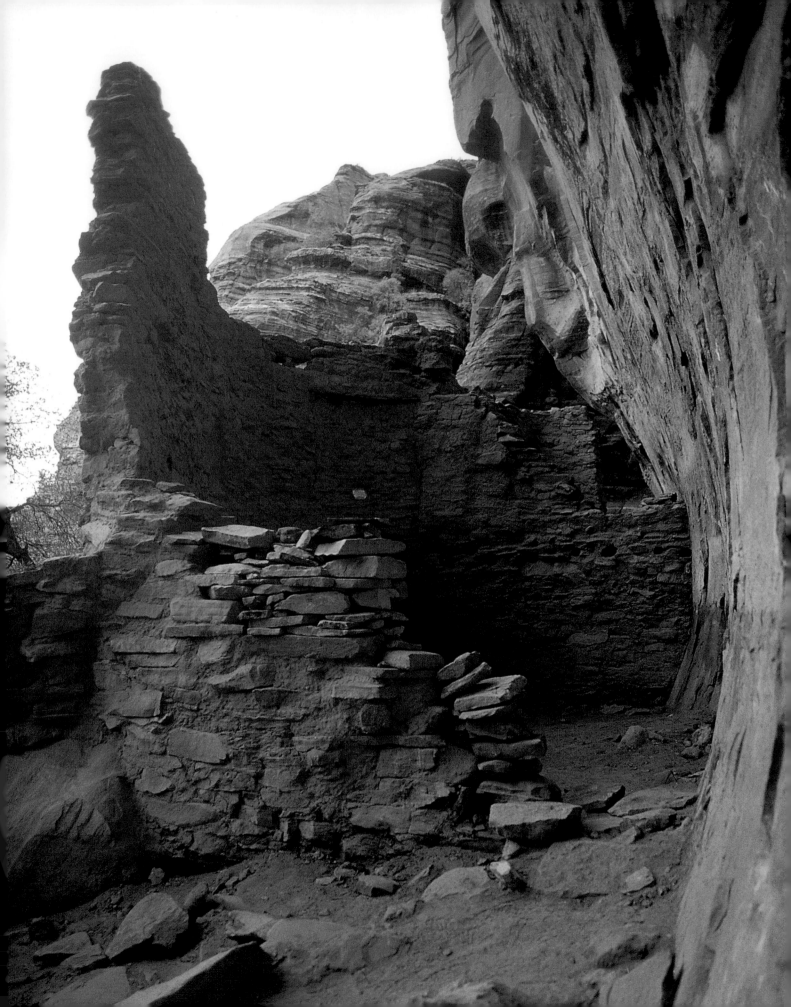

dwellings

A building is a string of events belonging together.

CHRIS FAWSETT

T he cliffs and canyons surrounding Sedona are richly scattered with the ruins of ancient Sinaguan communities whose inhabitants were the original masons and architects of the area. Their dwellings, which withstood the elements for hundreds of years, live still as vital inspirations for contemporary builders. As you place your thumb in a thumbprint left in the dried mud of an ancient ruin, you realize that its makers used the first building tool known to mankind, the human hand. Using mud, rock, and timber, local craftspeople use the same timeless tool to dovetail ancient techniques with modern construction.

Arriving with pack mules, horses, and covered wagons, pioneers settled in red rock country, staked out parcels of land, and built one-room cabins. These evolved into farm or ranch houses, extended one room at a time to accommodate growing families, while bunk houses were built for hired hands. Sedona Schnebly, the town's namesake and wife of its first postmaster, was also its first innkeeper, lodging weary travelers and serving them delicious meals in her roomy homestead on the site that is today home to Los Abrigados Resort.

Viewed from the pueblo room of this adobe home, an

arched opening into the front entrance hall features

tumbled stone floors and a vaulted timber beam ceiling.

The thick, rounded plaster walls are a perfect

background for Southwest art such as the refined

contemporary Native American pot by Richard Zane

Smith.

The Hanleys
discovered this
statue of Saint
Anthony in
Padua, Italy.
Dried roses from
Adrienne
Hanley's garden
nestle reverently
at its base.

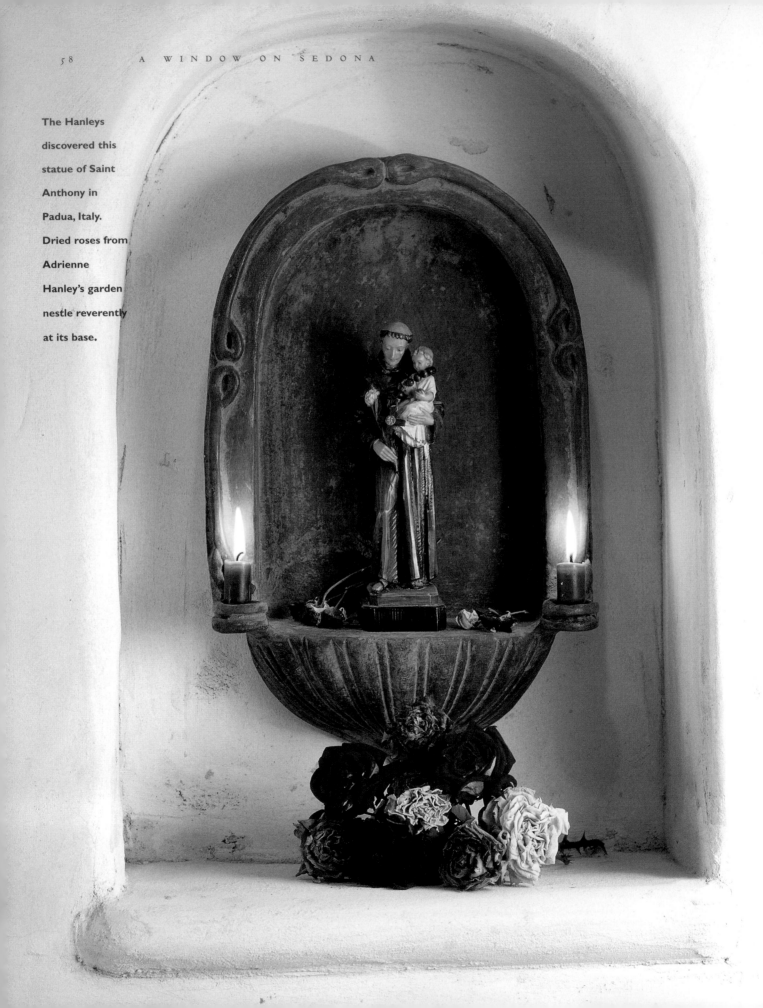

The pioneer spirit continues to draw toward Sedona people who are in search of simpler and more creative lives. Residents who have migrated from around the world express their individuality and their dreams through their dwellings. Exploring new options in design and decor becomes an adventure into uncharted territory. Some abandon the old trappings and "go Southwest" while others transplant old traditions into new soil. Still others weave old with new in a seamless blend. As in marriage, the door opens for fresh beginnings.

Adobe, country creek, British colonial, contemporary, lodgepole, rustic territorial, Spanish hacienda—all are the inspiration for local design, with consideration for red rock views their common denominator. Compound this focus with the efficient use of the sun's cycles and you get the best of both worlds, solar energy and views.

An antique mesquite table holds an assortment of colorful gourds. Growing up the branches of a juniper tree, their unplanned appearance in the garden was a magical occurrence. The rosewood box was specially constructed to support the Spanish Colonial sacristy door with hand-forged iron rosettes.

Layered into the contour of a
Sedona hillside is a Mexican
hacienda. Beyond a hand-
crafted stucco arch, old
mesquite doors open into a
shaded courtyard. The
uniqueness of the red rocks
from this setting is their
proximity. Although they
appear immense at such
close range, the formations
provide a surprising sense of
shelter and protection.

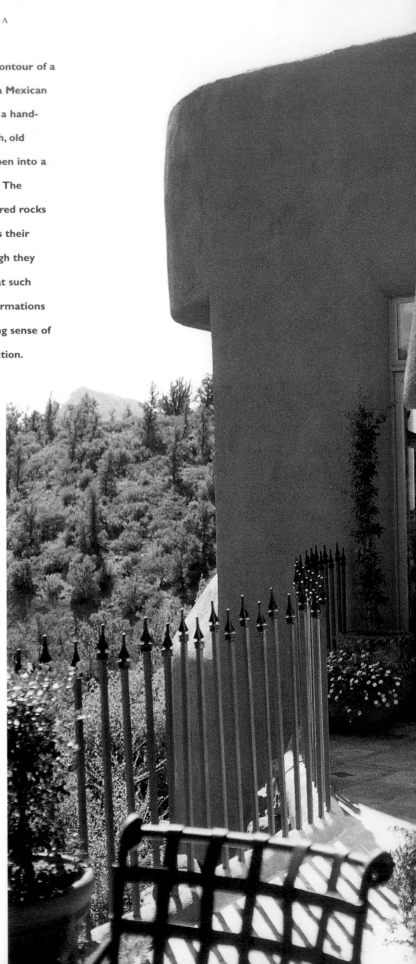

Originally in a Mexican church nicho, this
primitive pine cupboard holds a special place in
the master bedroom of the owners of Sedona's
Mexidona furniture shop. The Virgin of
Guadalupe rests atop the cupboard and a Russian
icon sits on the shelf inside the glass doors.

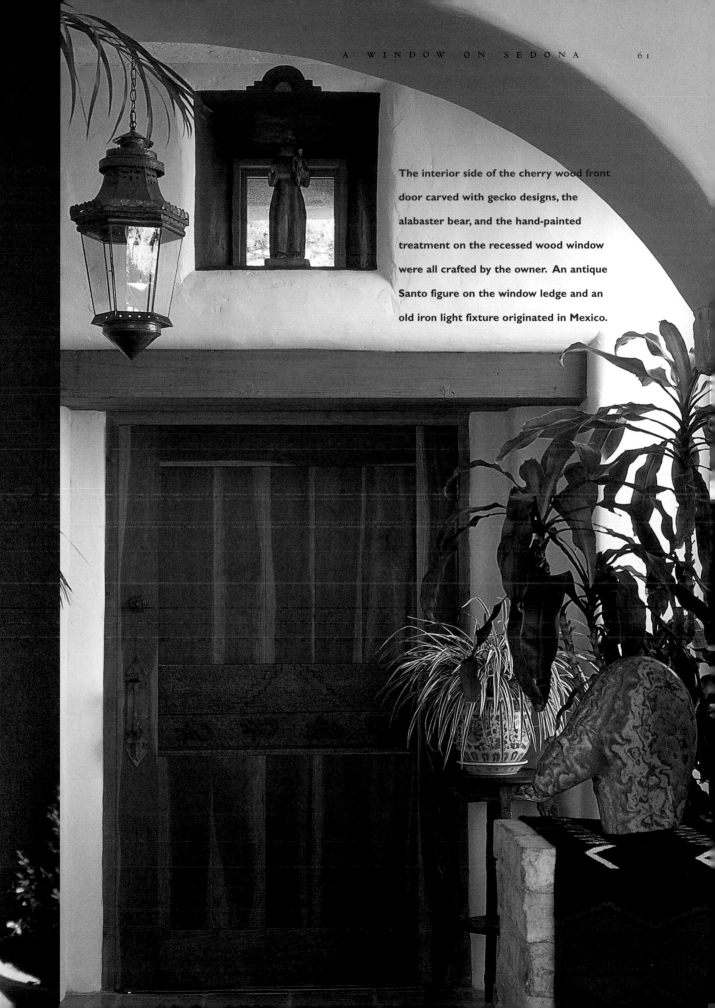

The interior side of the cherry wood front door carved with gecko designs, the alabaster bear, and the hand-painted treatment on the recessed wood window were all crafted by the owner. An antique Santo figure on the window ledge and an old iron light fixture originated in Mexico.

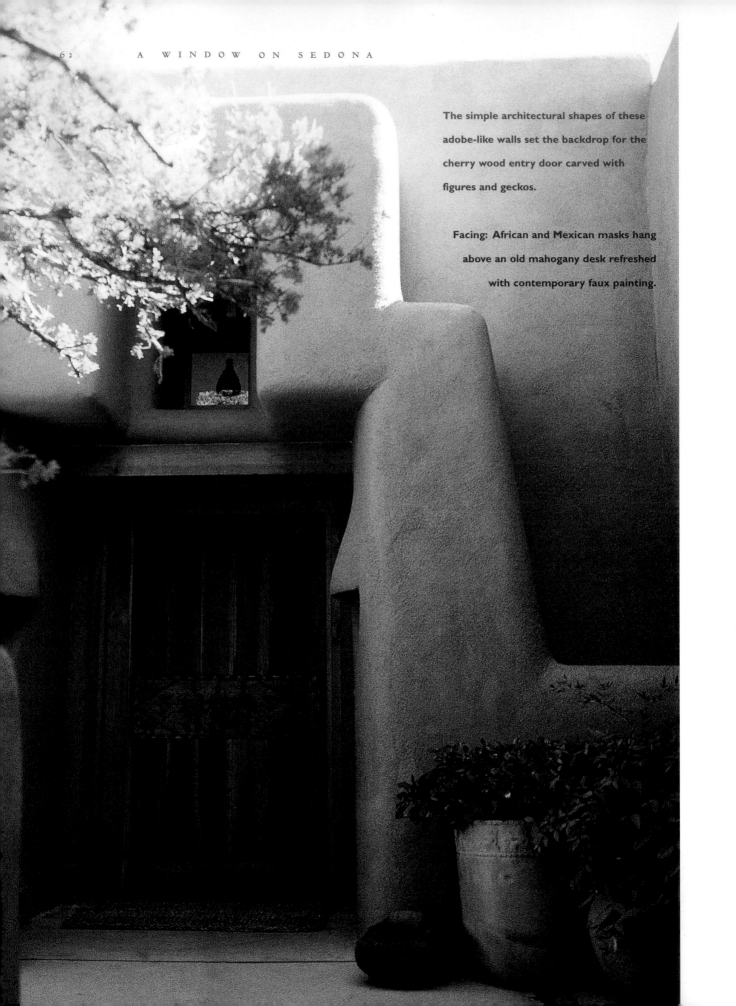

The simple architectural shapes of these
adobe-like walls set the backdrop for the
cherry wood entry door carved with
figures and geckos.

Facing: African and Mexican masks hang
above an old mahogany desk refreshed
with contemporary faux painting.

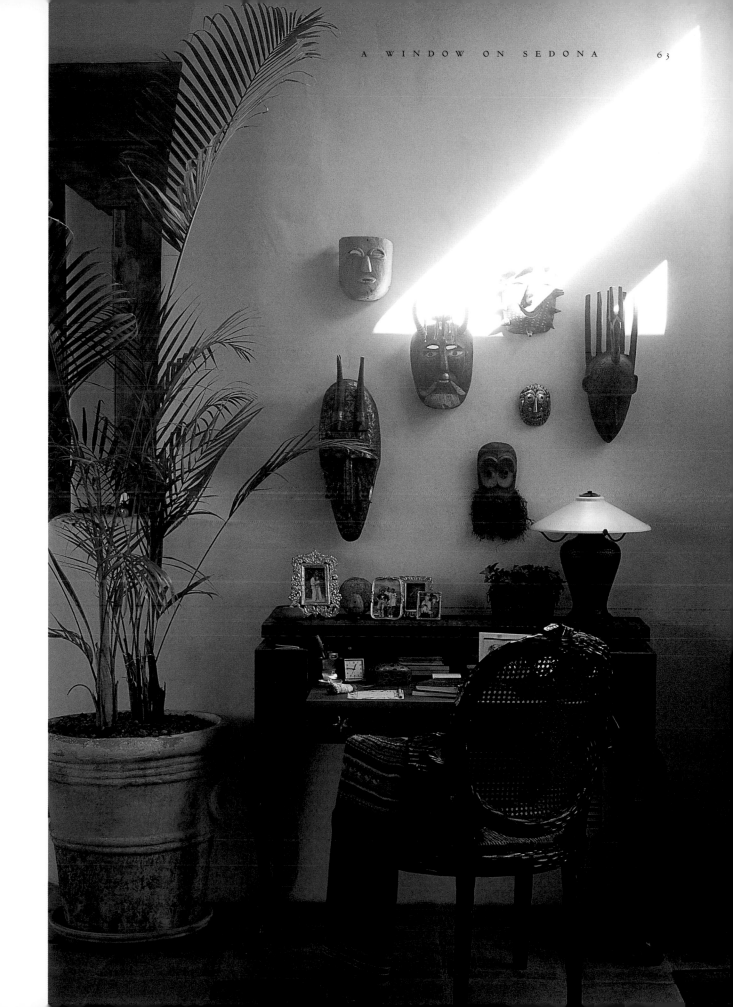

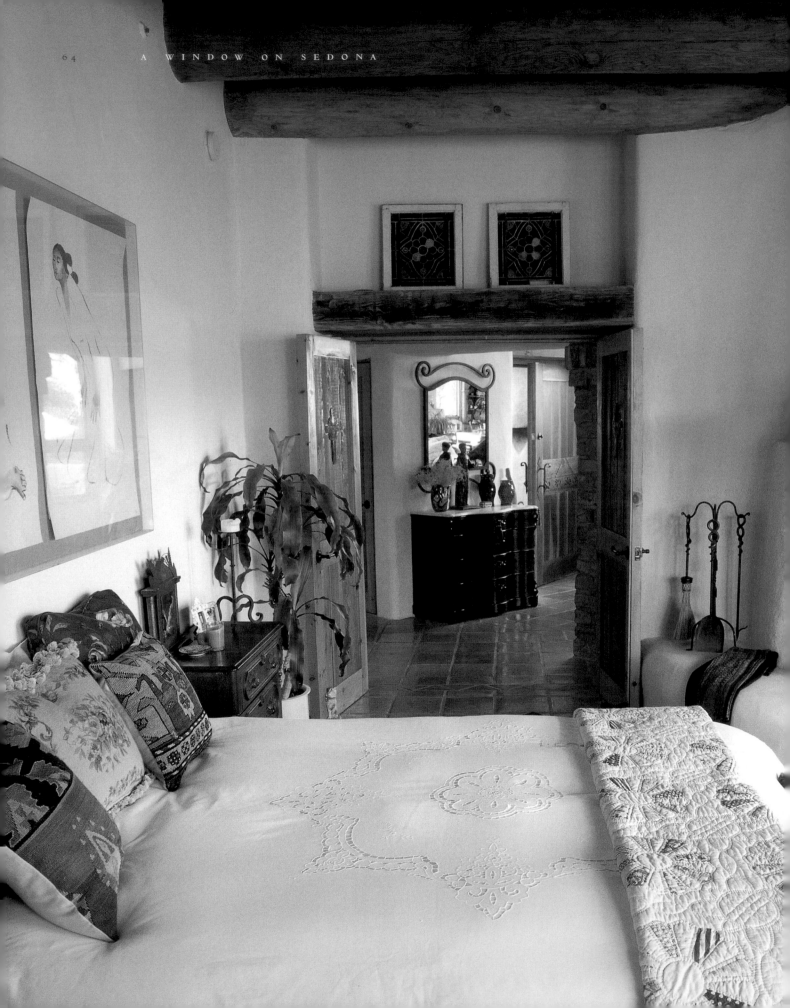

Ed Hanley built this curved-legged painted table, adding a bottom shelf for Adrienne's cookbooks. Navajo folk art sits atop the table and a collection of birdhouses hangs above it on the hand-troweled plaster wall.

Facing: Double doors of sugar pine lead into a master bedroom with vigas, lattias, and a beehive fireplace. Vintage stained glass windows rest on lintels made of wood that was once part of an old Utah bridge.

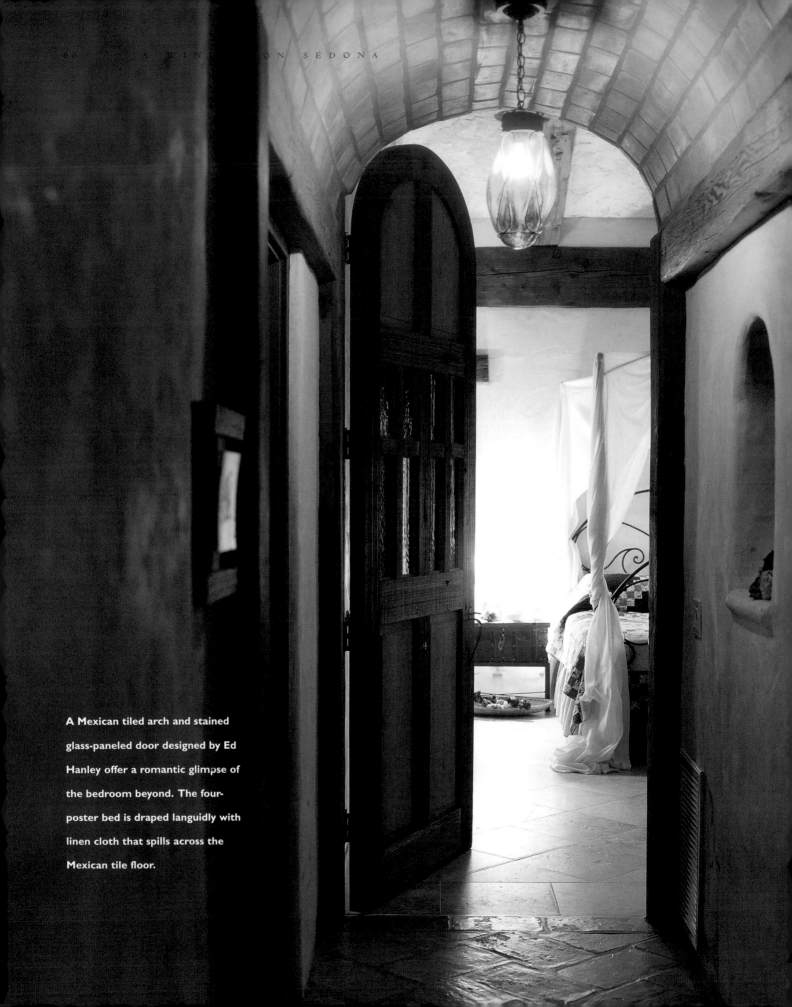

A Mexican tiled arch and stained
glass-paneled door designed by Ed
Hanley offer a romantic glimpse of
the bedroom beyond. The four-
poster bed is draped languidly with
linen cloth that spills across the
Mexican tile floor.

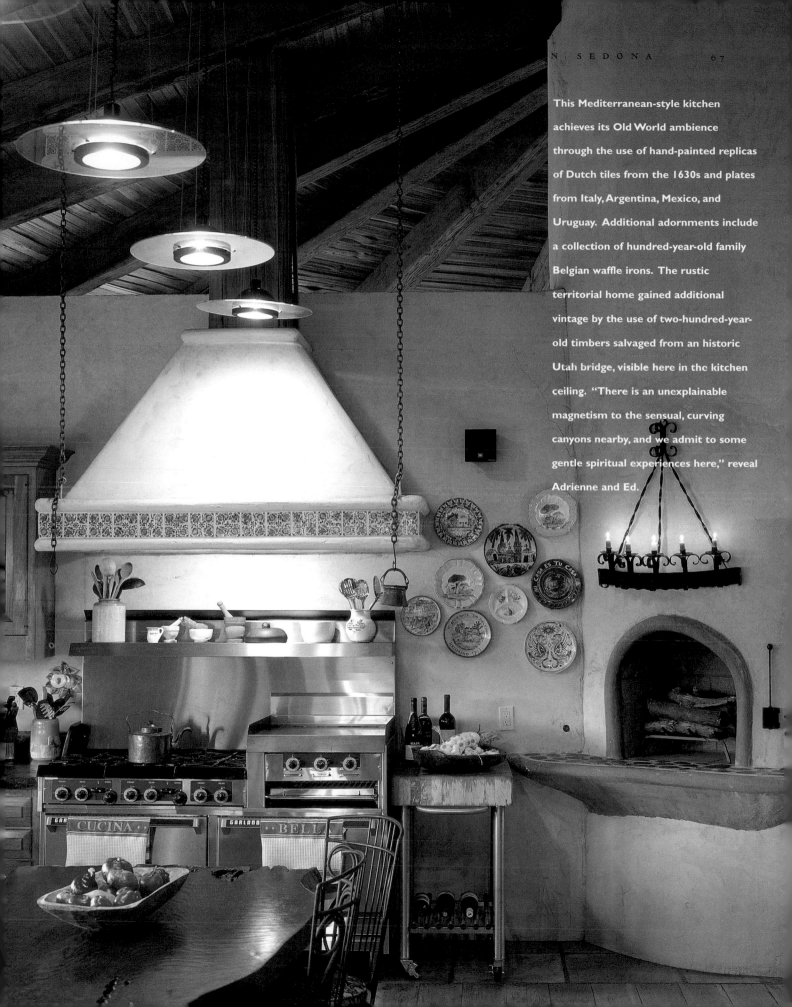

This Mediterranean-style kitchen achieves its Old World ambience through the use of hand-painted replicas of Dutch tiles from the 1630s and plates from Italy, Argentina, Mexico, and Uruguay. Additional adornments include a collection of hundred-year-old family Belgian waffle irons. The rustic territorial home gained additional vintage by the use of two-hundred-year-old timbers salvaged from an historic Utah bridge, visible here in the kitchen ceiling. "There is an unexplainable magnetism to the sensual, curving canyons nearby, and we admit to some gentle spiritual experiences here," reveal Adrienne and Ed.

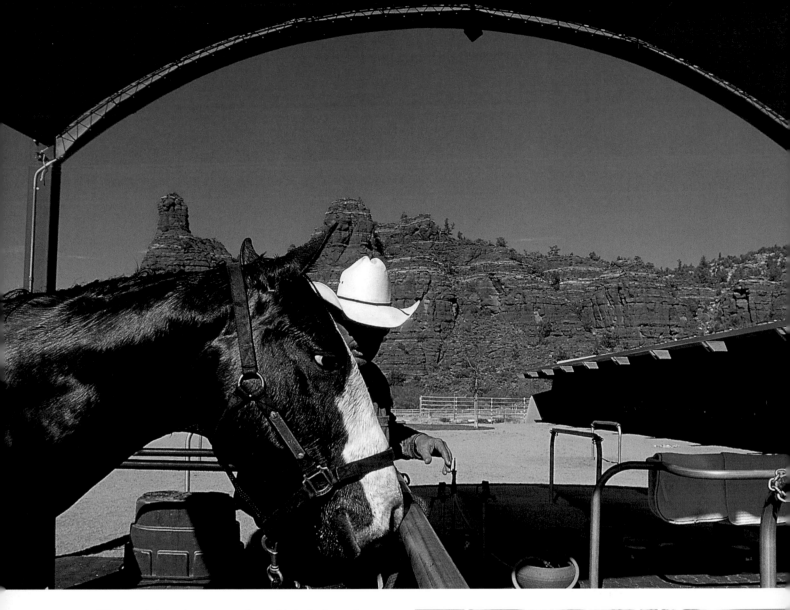

The barrel shaped structure where this lucky horse is bathed mimics the shape of the Offieids' "his and her" metal-roofed barns. Two barns allow for the distinctly different styles of horsemanship of the owners of El Rojo, a 200-acre ranch. Karin rides English dressage in national competitions and Jim rides western, competing in team roping.

The Offield house is a great example of Old West wed with contemporary styling. Red stone walls echo ancient cliff dwellings. Painted steel framed screen doors lead into an entryway with a metal air funnel to channel hot air away from the interior. The home rests on a bluff overlooking barns, pastures, and a private park that is contoured beneath the red rock cliffs.

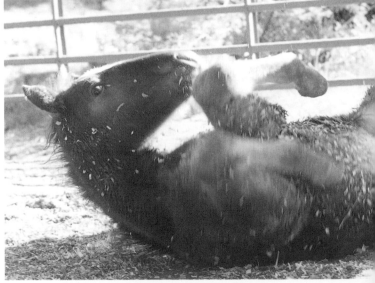

With one eye on his audience, Susan Kliewer's horse Little Joe, a Morgan breed, does a down-and-dirty backscratch.

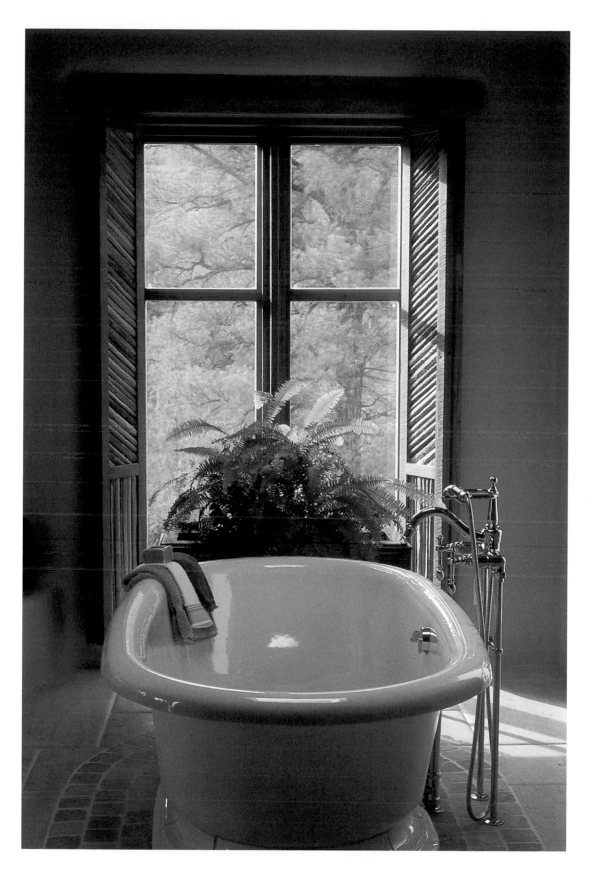

The placement of this bath takes advantage of the window view overlooking piñons and red rocks. A clear skylight above allows the stars to shine upon a leisurely late-night soak. Shutter inserts made of saguaro cactus ribs let light filter in and create patterns of changing shadow on the walls.

Facing: Sedona's landmark Coffeepot Rock is framed by a high window in an adobe wall. Below it, an antique English armoire holds family photos. An iron floor lamp with a rawhide shade casts inviting light for evening reading in this snug sitting area of the master suite.

Penstemon reflect into walnut-framed windows that also catch the red rock view. Below, in the indoor-outdoor living space of this adobe home a wicker sofa, iron chairs, and a built-in banco are centered around a table converted from old mesquite doors. A beehive fireplace takes the chill off the air in spring and fall. The flagstone patio is softened with planters, a hot tub, stream, and negative edge swimming pool with a granite rock water feature. A low adobe wall protects the perennials and spring bulbs from javelina.

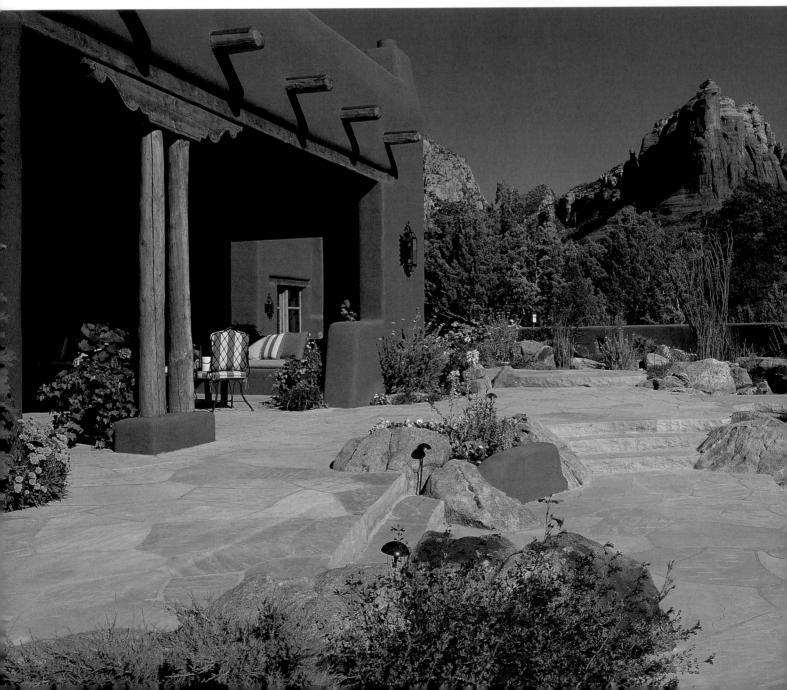

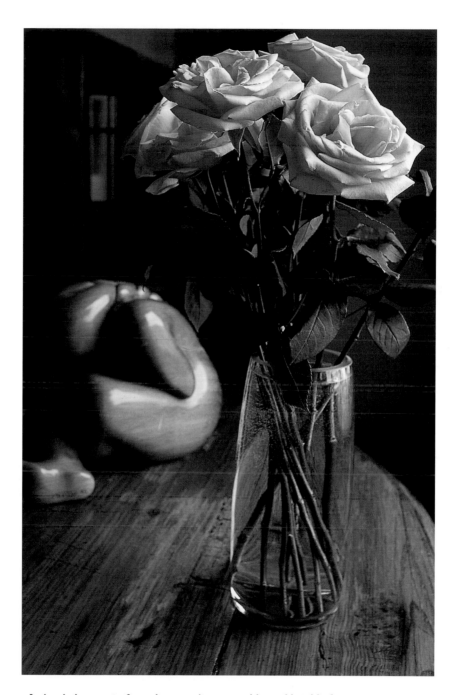

A simple bouquet of peach roses sits on an old monk's table from a
European monastery. Mike Medow, a Sedona artist, carved the wooden
figure of a woman with a braid. Natural cracks appearing in the wood
are filled with a turquoise and resin mix.

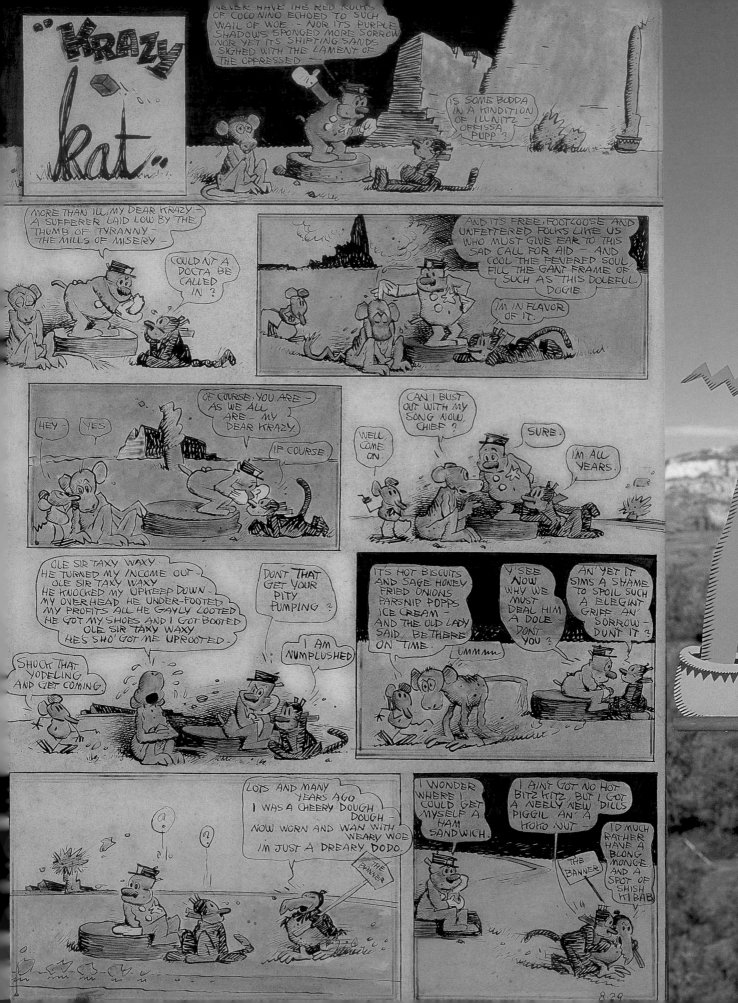

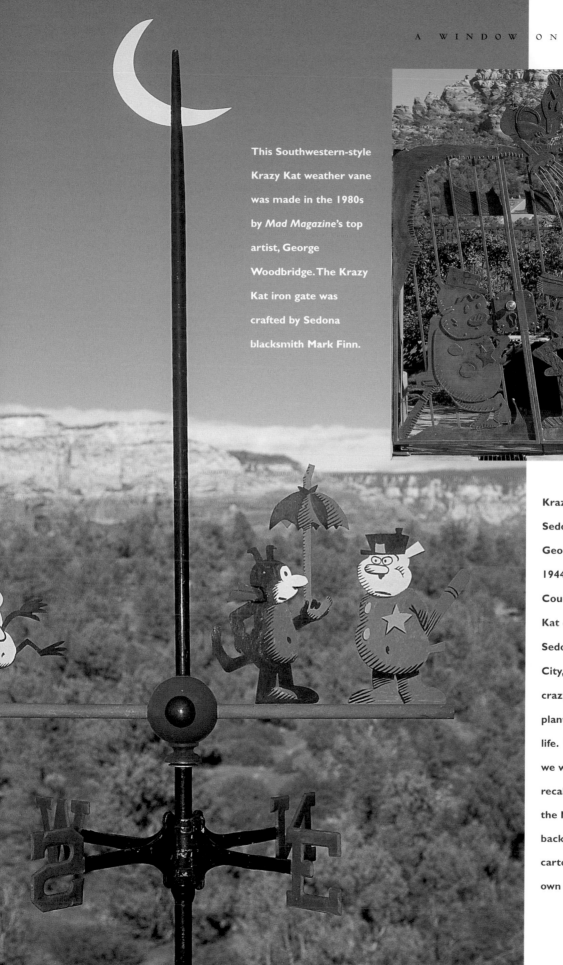

This Southwestern-style Krazy Kat weather vane was made in the 1980s by *Mad Magazine*'s top artist, George Woodbridge. The Krazy Kat iron gate was crafted by Sedona blacksmith Mark Finn.

Krazy Kat brought the Merolos to Sedona. The cartoon series, created by George Herriman between 1910 and 1944, used the red rocks of Coconino County as a backdrop. When Krazy Kat collector Pete Merolo visited Sedona from his home in New York City, he was astounded to see that the crazy rock formations and unusual plant life of the cartoons existed in real life. "We were blown away, and knew we would eventually relocate here," he recalls. The panoramic red rock scenes the Merolos first saw in the backgrounds of their Krazy Kat cartoon collection now glow in their own windows.

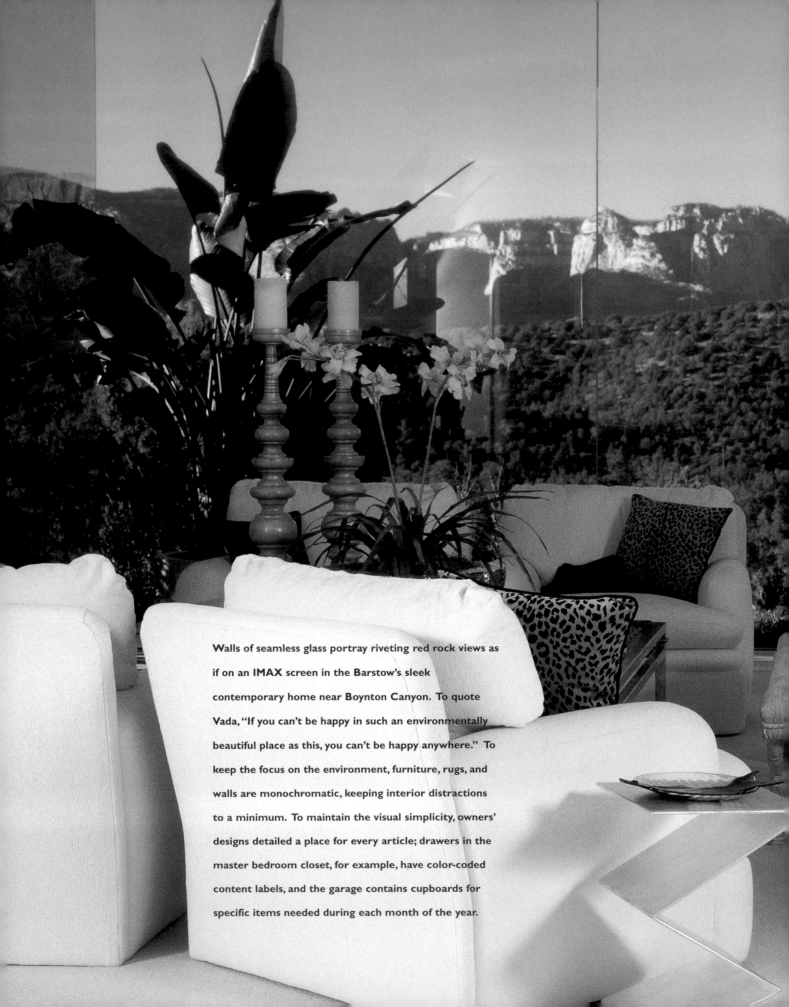

Walls of seamless glass portray riveting red rock views as if on an IMAX screen in the Barstow's sleek contemporary home near Boynton Canyon. To quote Vada, "If you can't be happy in such an environmentally beautiful place as this, you can't be happy anywhere." To keep the focus on the environment, furniture, rugs, and walls are monochromatic, keeping interior distractions to a minimum. To maintain the visual simplicity, owners' designs detailed a place for every article; drawers in the master bedroom closet, for example, have color-coded content labels, and the garage contains cupboards for specific items needed during each month of the year.

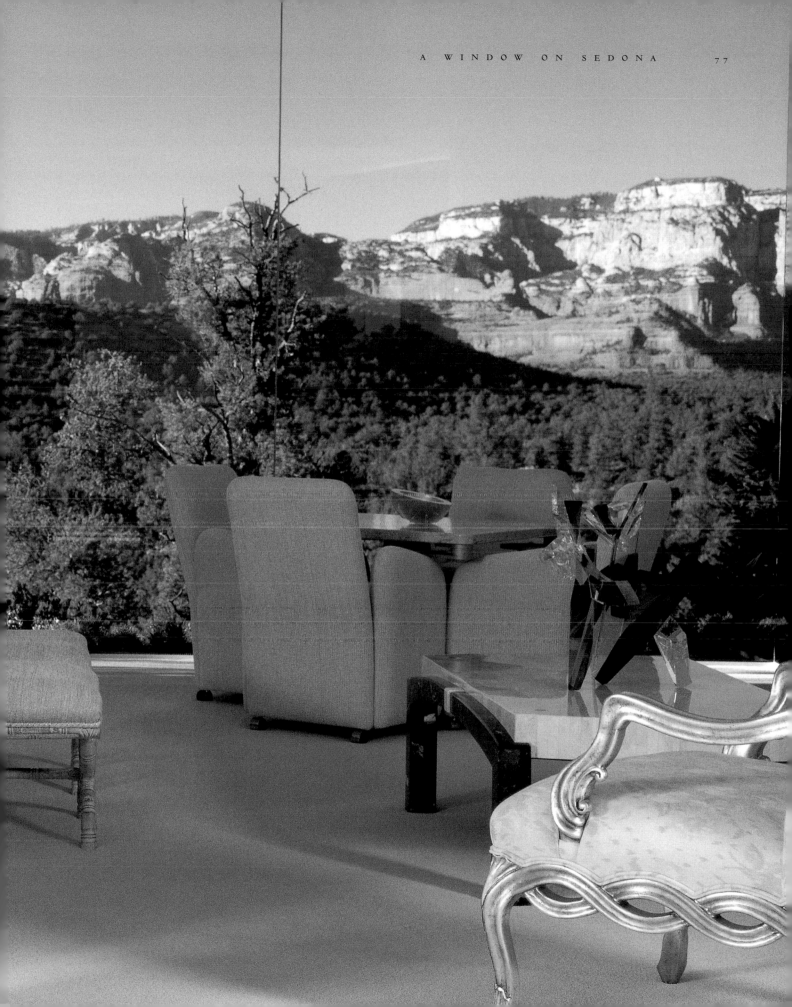

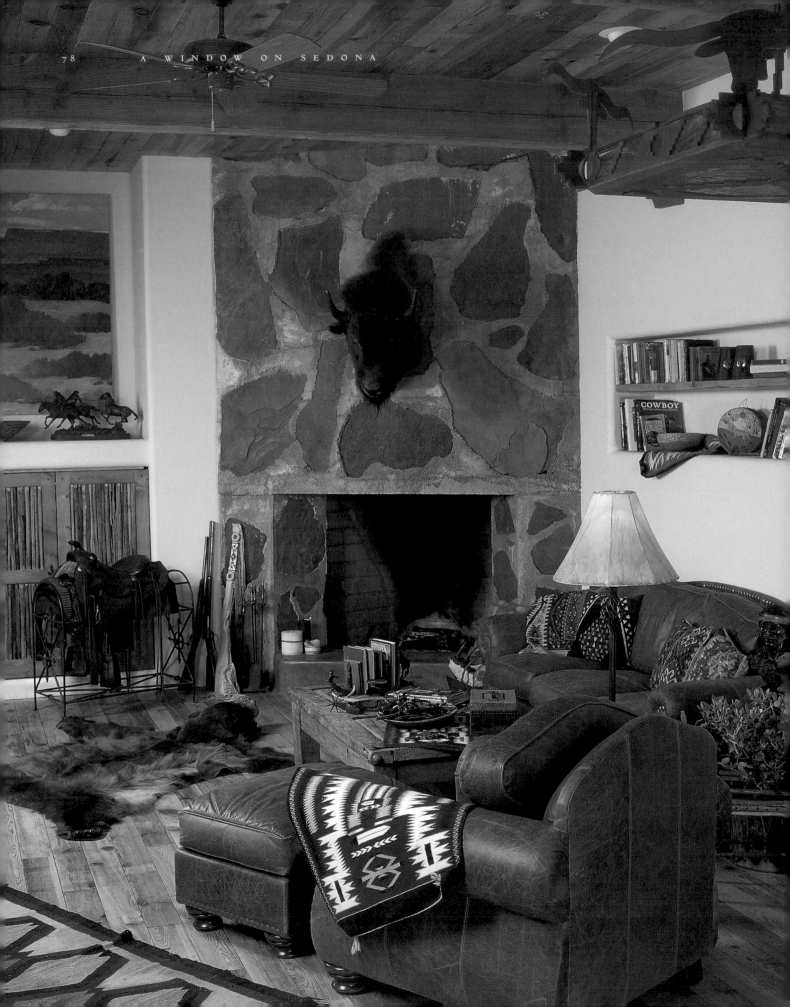

Built from a Taliesen West design, the beginnings of this house—a foundation, fireplace, and two rock walls—stood alone for twenty years. From these remnants, a cowboy actor and a renowned western artist, steeped in frontier tradition, created a Southwest territorial home. While sleeping in their tipi on the site, they dreamed of lodgepoles, rough-plastered walls, and hyacinth-painted window frames—and the dream came true. In this room, a 1920s leather saddle gives a feeling of the true West. The bronze sculpture is by Susan Kliewer. Wood used for the ceiling and floors is hundred-year-old pine found in a Flagstaff lumber mill. Susan Kliewer and Jeff Dolan met on a trail ride, first kissed at Merry-Go-Round Rock, married on Schnebly Hill, and put their horses in the same corral. Jeff, originally from the East Coast, acted in the movie *Tombstone,* and is currently acting in and producing Western docudramas. Says Jeff, "I even got to marry my very own cowgirl."

A Mexican pine buffet displays dishes and mementoes under wood-framed windows opening out upon the tipi frame. When covered, the tipi makes a unique guest house, cozy even in winter with its central firepit for warmth.

The horn-legged chair was purchased in a Montana
antique shop. Perched on its arm is an old-style,
very authentic Sugar Loaf cowboy hat that Jeff
wore while acting in western movies.

The Longpres, who retreat to Sedona from
Newport Beach, California, love "drinking in the
good feelings here." Mary Longpre has loved
Sedona since she saw it for the first time as a child.
At right, a deer antler chandelier hangs above a
traditional fruitwood dining table. The guest of
honor is "Sacajewea," dressed by Mary Longpre. A
colorful raku pot was fired by a local artist.
Spacious windows look out onto Boynton Canyon.

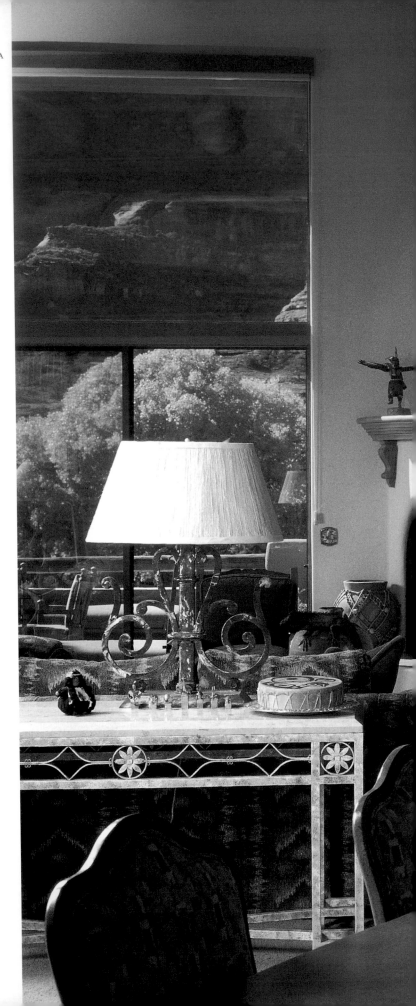

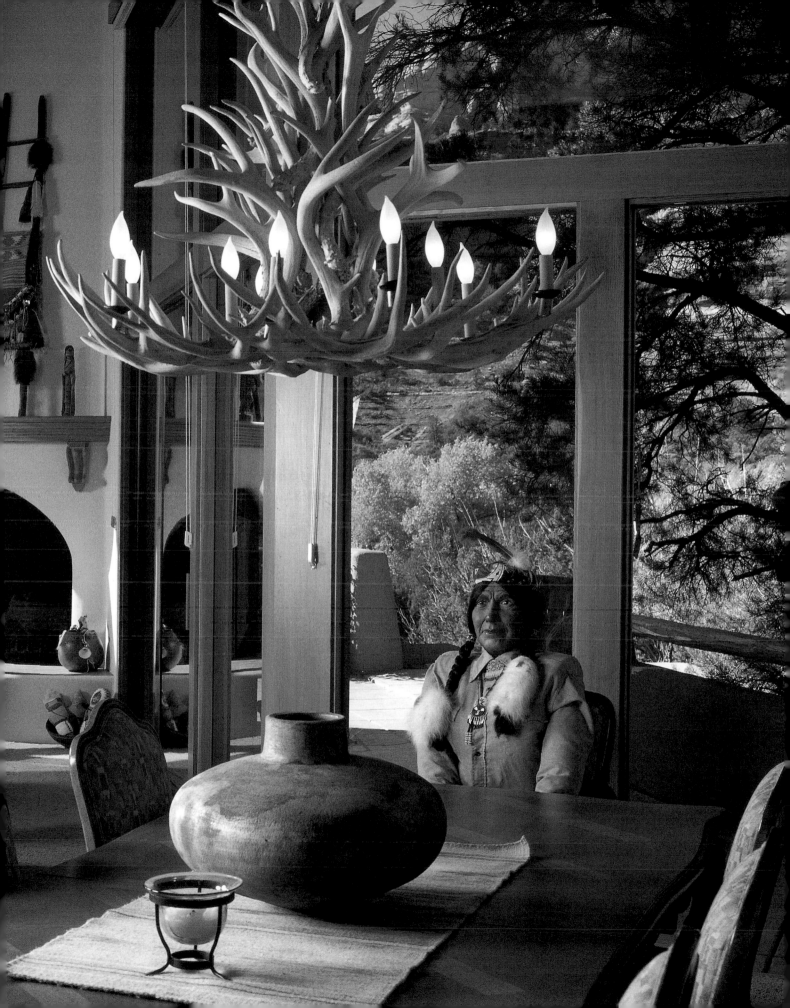

Steve Purtymun moved his family down to Oak Creek from Flagstaff in order to grow fruit and vegetables in the late 1880s. He lived in a tent while building his cabin from trees felled on the property and digging irrigation ditches to obtain water from the creek. He also built the trail leading to Flagstaff. The homeowners who live on the original Purtymun homestead share this cabin today for use as guest quarters.

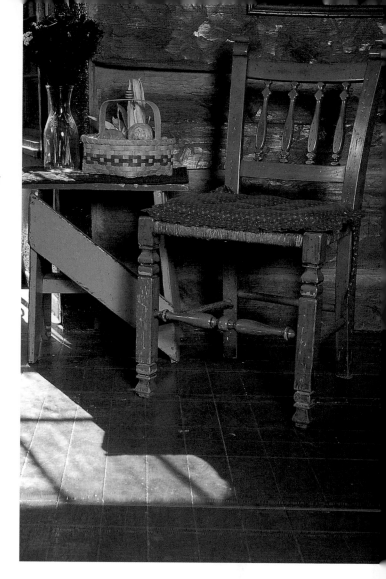

WE SHAPE OUR BUILDINGS;

THEREFORE THEY SHAPE US.

..

Winston Churchill

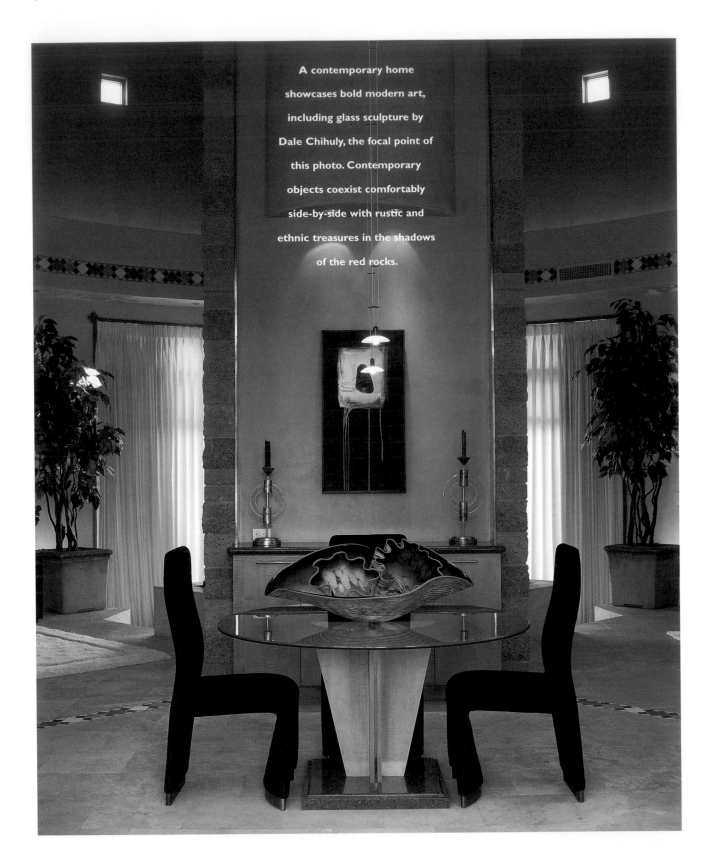

A contemporary home showcases bold modern art, including glass sculpture by Dale Chihuly, the focal point of this photo. Contemporary objects coexist comfortably side-by-side with rustic and ethnic treasures in the shadows of the red rocks.

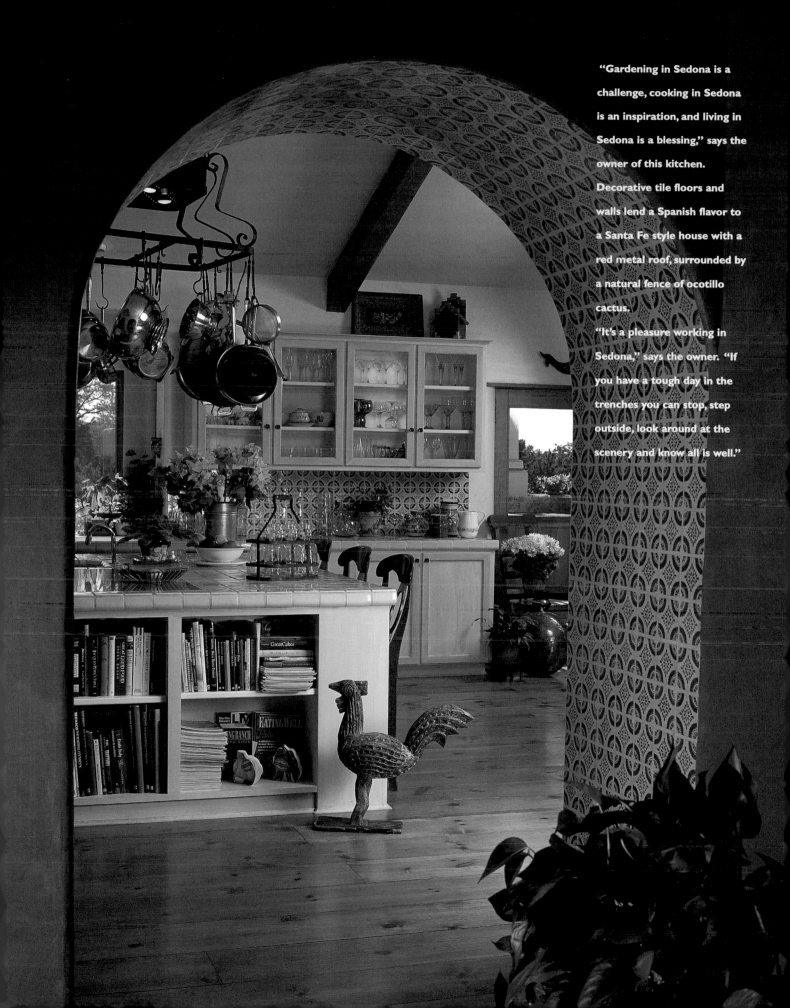

"Gardening in Sedona is a challenge, cooking in Sedona is an inspiration, and living in Sedona is a blessing," says the owner of this kitchen. Decorative tile floors and walls lend a Spanish flavor to a Santa Fe style house with a red metal roof, surrounded by a natural fence of ocotillo cactus.

"It's a pleasure working in Sedona," says the owner. "If you have a tough day in the trenches you can stop, step outside, look around at the scenery and know all is well."

Along the path to the Harper's house at Hidden Valley Farm, you encounter vegetable gardens, birdhouses on stilts, Belted Galloway cattle from Scotland (also called "Oreo cookie cows"), llamas, and horses grazing in divided pastures, and apple orchards. "Our place," Sharon comments, "is modeled after the British colonial homes of East Africa, which we saw while doing volunteer work in Kenya."

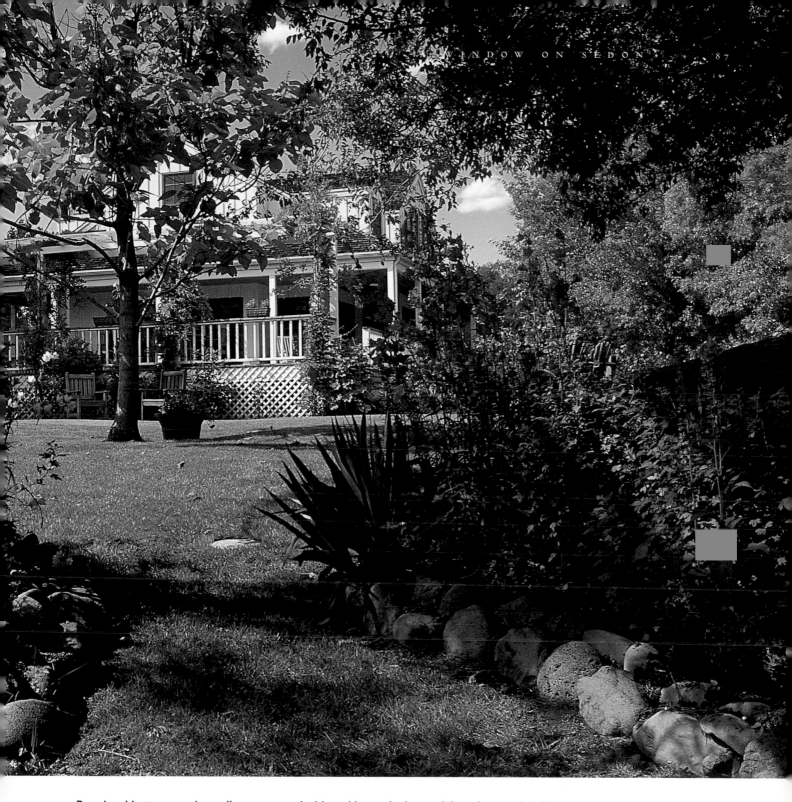

Board-and-batten exterior walls are wrapped with a white-washed verandah, and a raised, trellis-covered

foundation supports the two-story gabled structure. Interior walls display an occasional hand-painted

trompe l'oeil farm scene. Weathered plank floors, slate counter tops, and American folk art furnishings

complete the warm, cozy ambiance. One side of the verandah opens onto a grassy tree-lined

meanderland stretching along the banks of the lazily flowing creek, home to several species of

domesticated ducks and geese. Irises, pansies, statice, hollyhocks, and various annuals and perennials

bloom near the house.

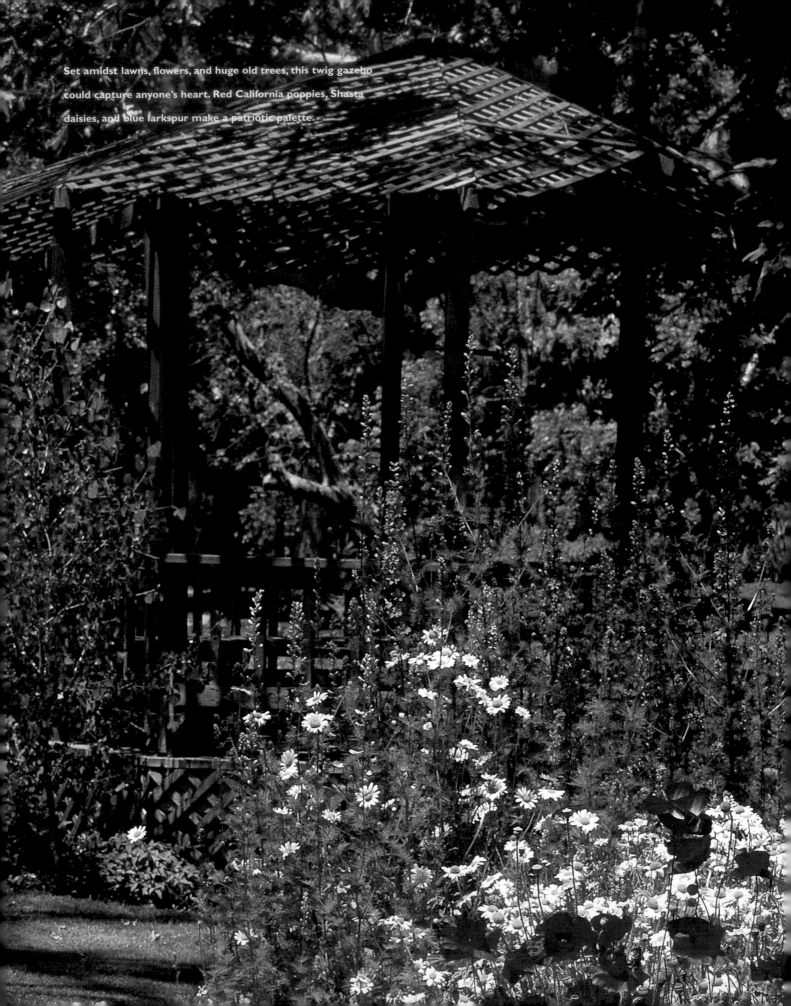

Set amidst lawns, flowers, and huge old trees, this twig gazebo could capture anyone's heart. Red California poppies, Shasta daisies, and blue larkspur make a patriotic palette.

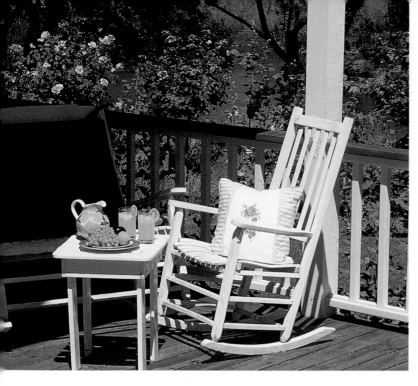

Lemonade and
rocking chairs are
at home on a
Victorian style
creekside porch.

Sharon's collection of birdhouses are apt to appear anywhere
inside and outside her home—on walls, in gardens, on benches—
or, like this one, creating the centerpiece for an antiqued dining
table overlooking the creek.

River rock columns and a
hand-crafted sign signal
that you have arrived at
Hidden Valley Farm.

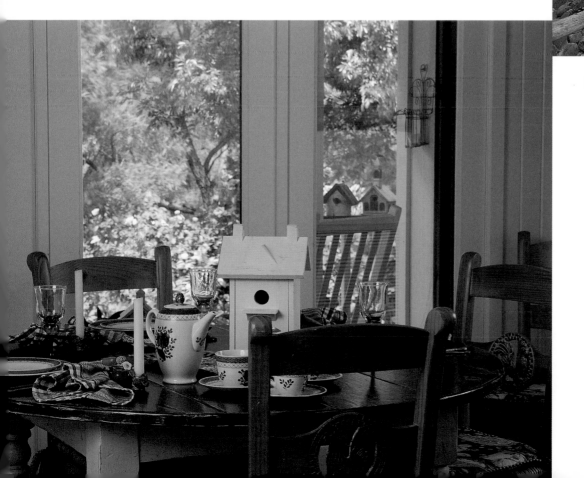

Wicker and iron furniture beckon you to sit and
enjoy the creekside scenery reflected in the windows
of this back porch.

Native river rock, collected at the creekside, was used to build
this two-story-tall fireplace with a rusted iron screen crafted
by Excalibur. Casablanca lilies in a china pitcher soften the
rough textures of stone, concrete, leather, and pine.

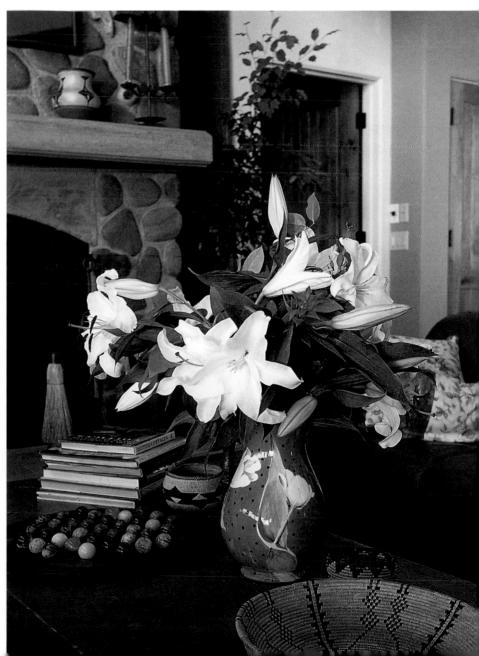

This home overlooking Oak Creek makes use
of river rock for exterior walls, columns,
patios, and a retaining wall for a picket-fenced
vegetable garden. Inside, masculine tan
leather sofas combine with feminine blue
floral linen fabrics and heart collectibles to
create a cheery country feeling. Phil, whose
family has been in Sedona since the early
1900s, remarks that "When the rocks turn
crimson at sunset, nothing is more relaxing
than sitting in privacy on the back porch,
wine in hand, observing the wildlife along the
creek. Witnessing a bald eagle compete for
fishing rights with a blue heron, and watching
the ducks float by is a great way to unwind
after a challenging day's work."

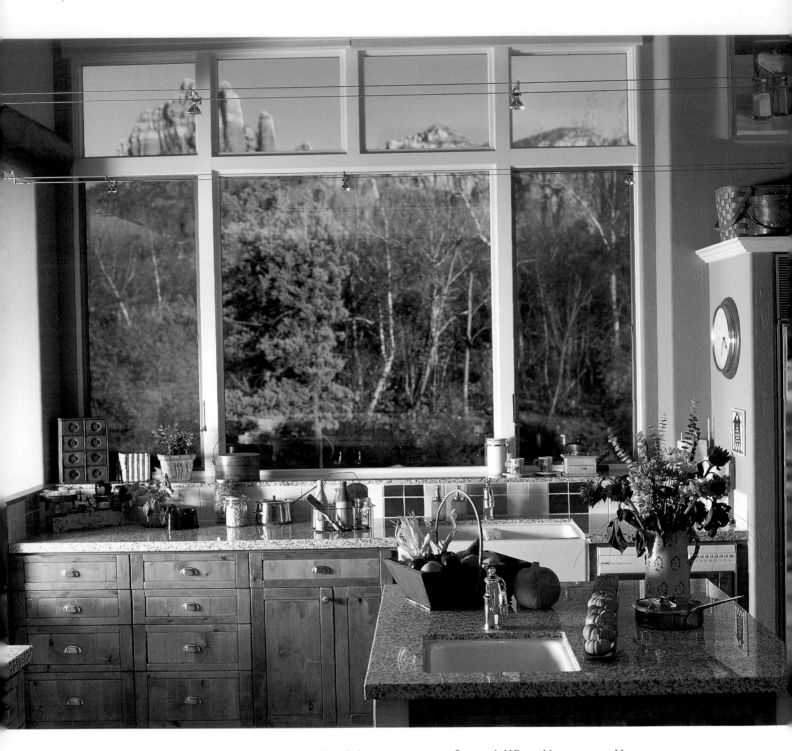

A view of Camel Rock from this kitchen lights up at sunset to fiery red. When this occurs, cooking

activity is put on hold while the chef enjoys one of nature's spectacles. Knotty alder cabinets,

speckled granite counter tops, pine logs, and barn-red glass-fronted cupboards combine with

antiques to create an old ranch house atmosphere. Halogen lighting hung on wires was the answer

to the problem of lighting from a twenty-six-foot ceiling, and added a contemporary diversion.

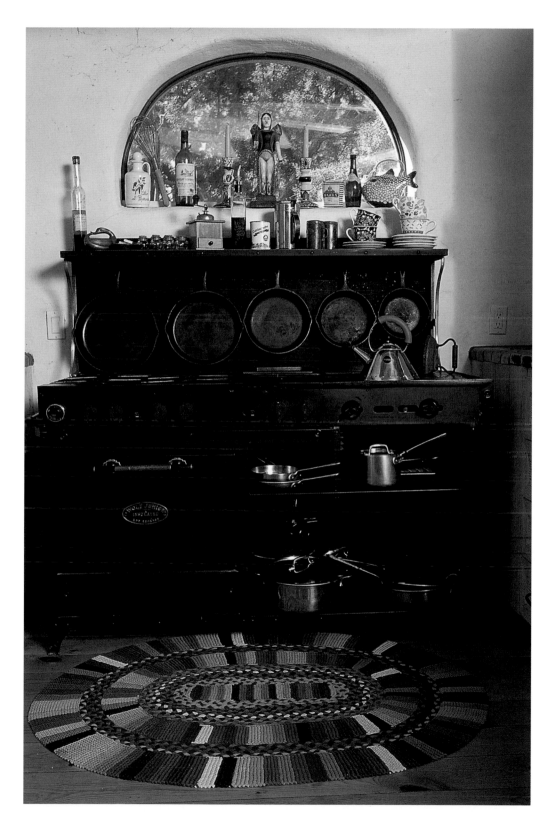

Below the arched window with its views of Boynton Canyon sits a 1940s Wolf range from an antique shop in Dewey, Arizona, holding a collection of vintage cast-iron skillets. Across the top shelf are cooking oils and a New Mexican santos of the Archangel Rafael, circa 1900s. The colorful cotton rag rug was designed and woven by artist Judy Boisson.

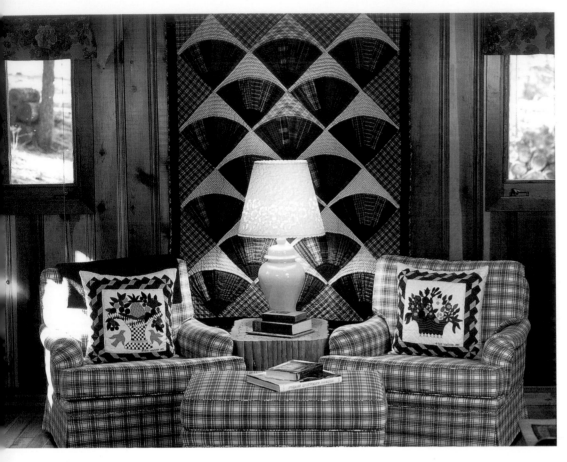

Light glows from a cut-paper shade topping a ginger jar lamp. The quilt hanging between two plaid chairs is designed after the Grandmother's Fan pattern. Windows and knotty-pine walls in this restored cabin date to 1946.

Oak Creek Canyon is filled with get-away cabins nestled in the woods and dotted here and there along both sides of the roadway. Legendary Western author Zane Grey wrote *Call of the Canyon* here. The cabin shown above and at right satisfied the hunger for a little country in the lives of a Minnesota couple who relocated to Sedona and built a Southwest contemporary home some years ago. In the nearby woods, they found a cabin, a tiny 1946 fixer-upper, and with vision, vigor, and many months of labor they winterized this cozy one-bedroom forest dwelling. Edible handouts encourage stellar jays, Abert squirrels, and grey foxes to the hideaway. "Stuff we think is so important before we leave for the cabin becomes an 'oh well' once we get here," says Chuck. It's not so much a get-away *from* something place as a get-away *to* something place."

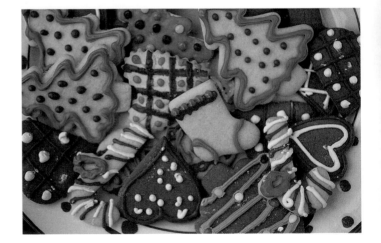

River rock was carried to this site by the owners to renovate the fireplace. Mary's family heirloom clock rests on the Arizona flagstone mantel. The mountain cabin is ready for a cozy canyon Christmas.

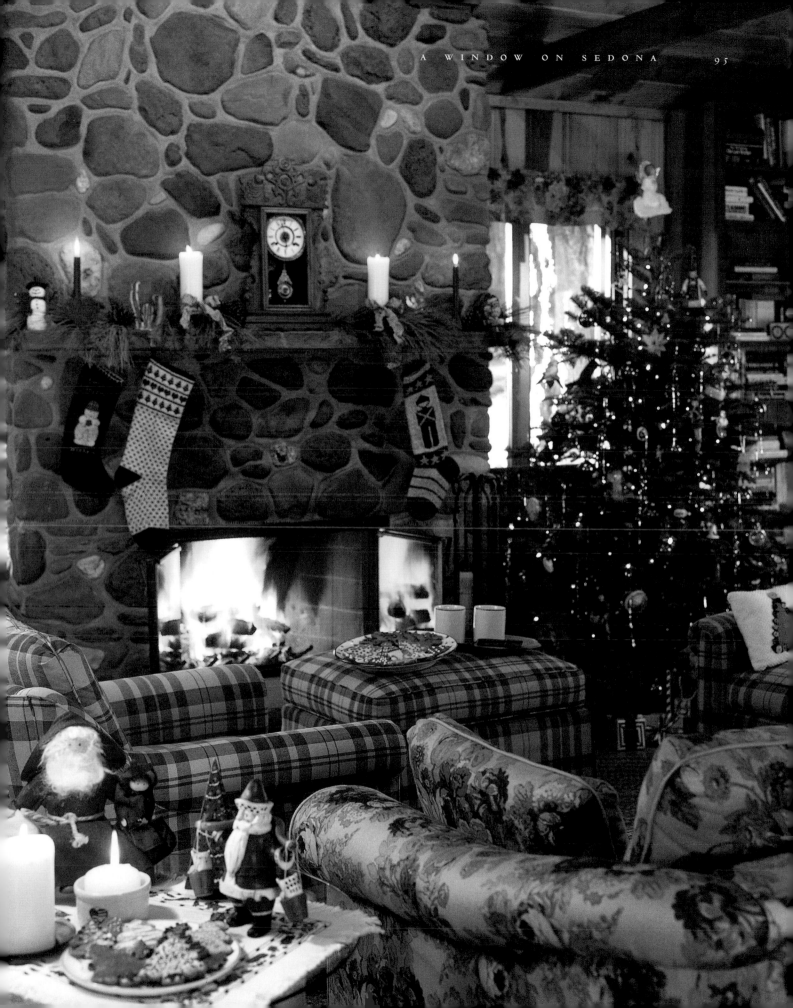

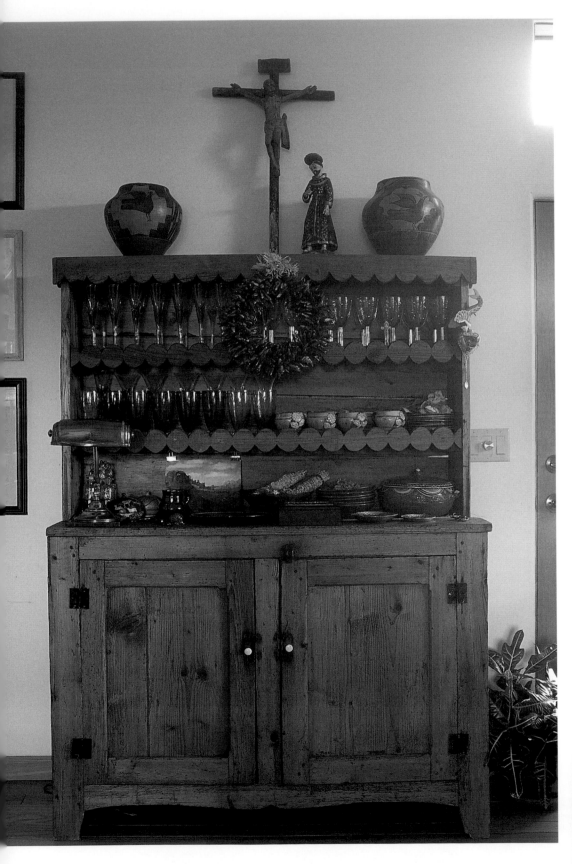

An early 20th-century Spanish Colonial pine hutch holds glassware and Mexican pottery. The religious objects, a *Christo* and a late 18th-century figure of Saint Francis flanked by two early 20th-century Zia pots, reflect the owner's fascination with objects that distill the purity and passion of faith. The small oil sketch portrays one view from the property; it was painted by an artist friend, Bill Wyles, when he visited.

Facing: The house is built around a central courtyard with miniature fruit trees, and a pair of elderberries beloved by the birds.

Whimsical gifts are at home in this eclectic environment.

THERE WAS A SWEET TANG OF CEDAR
AND SAGE ON THE AIR AND THAT
UNDEFINABLE FRAGRANCE PECULIAR
TO THE CANYON COUNTRY OF
ARIZONA

Zane Grey

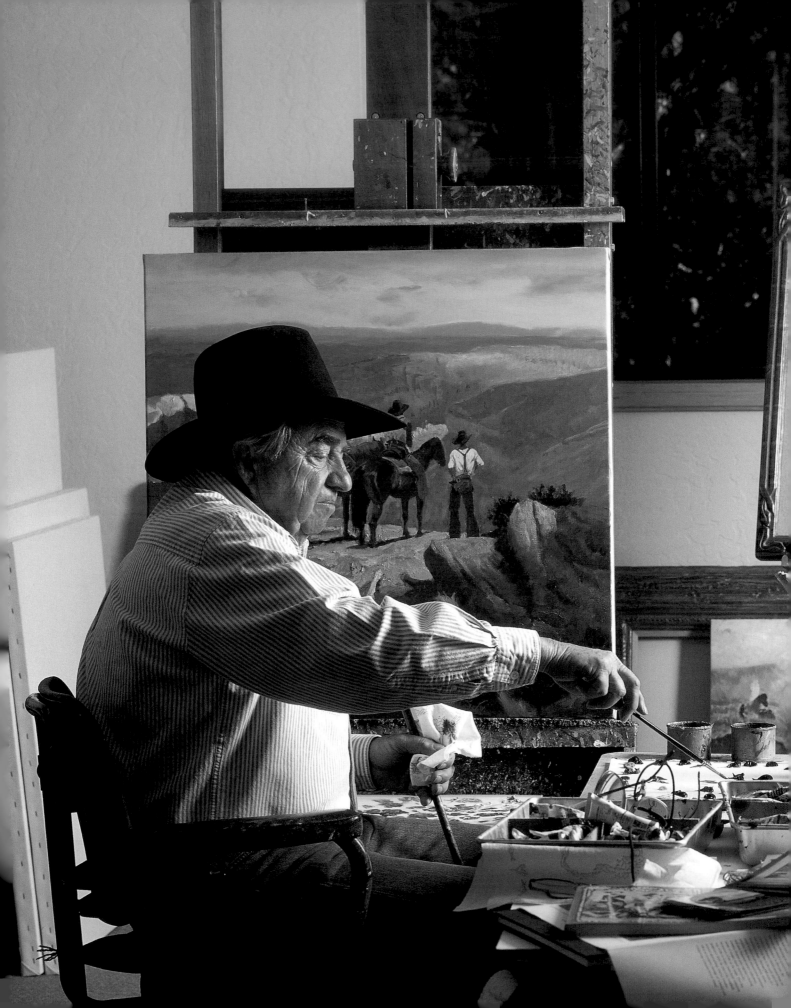

community

Art is man's nature; nature is God's art. — P. J. BAILEY

Forty years ago Joe Beeler and his wife Sharon impulsively packed up all their belongings and moved from Oklahoma to Sedona in a 1954 Chevy truck with a U-Haul attached, not knowing a soul. They have been here ever since, while Joe has made friends and history all over the world with his talent for painting and sculpting the American West. Beeler, who is part Cherokee, helped found the Cowboy Artists of America at the Oak Creek Tavern in 1965. His works have made their way into ranch houses throughout the West, and into museum and big-city collections throughout the world. Says this easy-going fellow who loves to ride, cow punch, camp, and hunt, "I feel fortunate to live and earn a living in Sedona. The real magic here is the beauty of the light and color in the canyons, not the woo woo or mystical selling of a myth."

The red rock area was inhabited by Native tribes for hundreds of years. Around 1875, western settlers arrived to build new lives in the canyons and along the creeksides. Reading their history fortifies our respect for those who persevered to stay, for, in spite of its fantastic beauty, the place was remote and the process of settlement arduous. Amazing as it is, newcomers today experience, in an updated version, an echo of the difficulties and hardships of the early settlers. Many arrive with sufficient funds to exist without further work in this community of some 15,000 souls, but others bring only an optimistic attitude and a belief that they can survive, fueled by the magnetic draw of the vistas and terrain.

BACK O' BEYOND RD

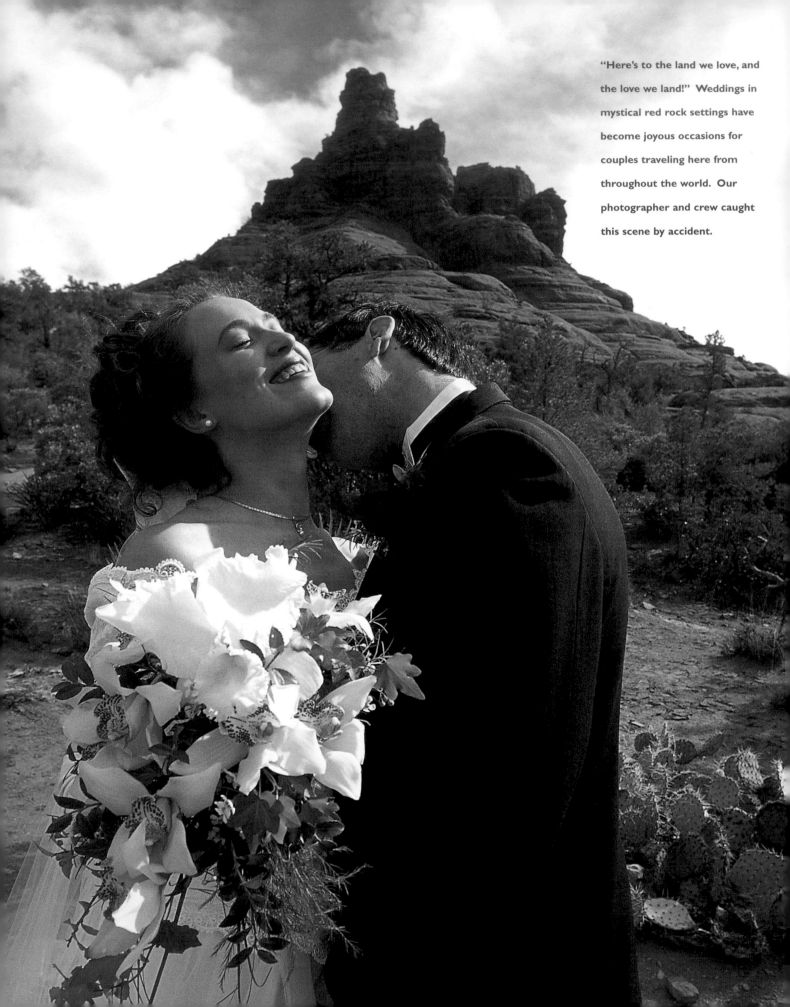

"Here's to the land we love, and the love we land!" Weddings in mystical red rock settings have become joyous occasions for couples traveling here from throughout the world. Our photographer and crew caught this scene by accident.

Packets of perennial flowers will keep the memory of a Sedona garden wedding alive for years to come.

All newcomers experience the impact of starting over, with families and friends, familiar territory and tradition, left behind. The story is often heard of people who arrive for the first time simply as casual visitors, leave with the deed to a parcel of land or an existing house, and return home just long enough to pack up. Others plan their relocation for years, wrapping up their lives elsewhere to start anew amid the red rocks. Some are worldweary and in search of refuge and renewal. Some are drawn to enclaves of alternative spiritual practice. Few places of Sedona's modest size draw so many people who have consciously, willfully, elected to live in them, and are not citizens by birth or default.

Young families seeking a rural environment arrive and find ways to prosper. Both wellto-do and budgetminded retirees are a large segment of the population. Another group includes midlife professionals who work from home, traveling as need dictates. Some cannot afford to live locally but choose to work in this destination resort town, driving in each day from surrounding areas. Others live and work amid the red rocks, but keep two jobs, or three, just "to be here." Parttime residents and repeat tourists make red rock country a periodic waystation for rest and rejuvenation. With this melting pot of people, we are privileged to celebrate many lifestyles.

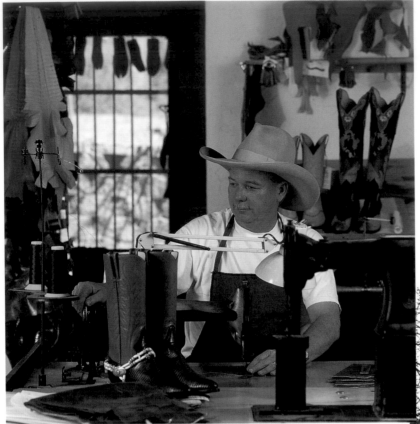

Old Western storefronts at the Bradshaw Ranch are reminders of the glory days of Wild West movie-making. Movies shot in the Sedona area starred John Wayne, Jimmy Stewart, Jeff Chandler, Debra Paget, Gail Russell, Kenny Rogers, Linda Evans, and even Elvis. Bob Bradshaw, the original owner of this ranch, scouted locations and acted as an extra in many of the movies filmed on his land. He is a landscape photographer and has published several books on Sedona.

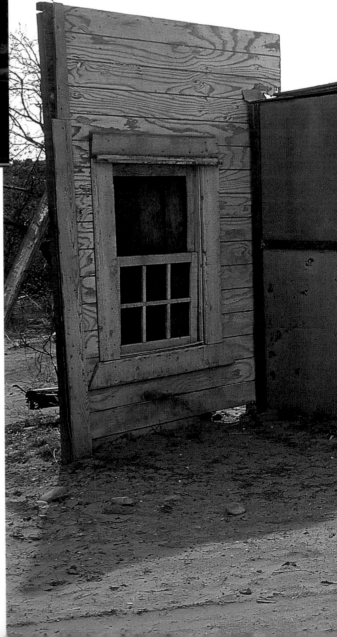

Sedona's bootmaker Bob McLean has years of designing and stitching under his belt, and a six month's waiting list to boot! Bob and his wife visited from Vermont, saw a cobbler's shop for sale in nearby Prescott, and within a day changed their lives forever. Bob apprenticed under legendary Paul Bond, but says it took eight years of diligent practice before he made what he considers a fine boot. McLean's bootmaking skills are a combination of patience, artistic flair, strong and agile hands, a meticulous nature, and an ability to interpret and transform the customer's idea into a comfortable functional product.

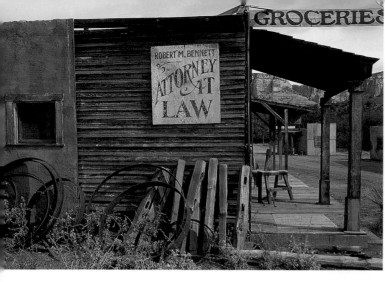

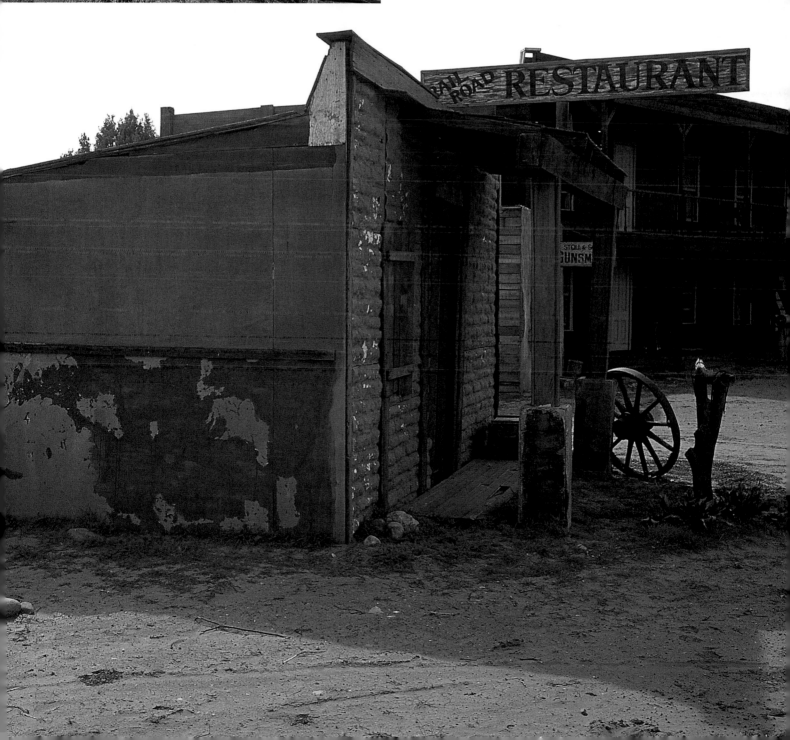

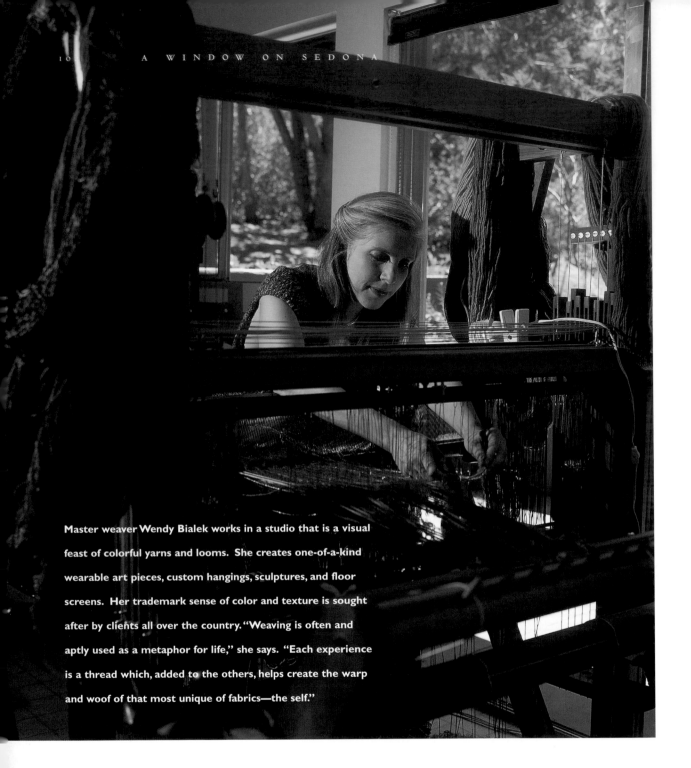

Master weaver Wendy Bialek works in a studio that is a visual feast of colorful yarns and looms. She creates one-of-a-kind wearable art pieces, custom hangings, sculptures, and floor screens. Her trademark sense of color and texture is sought after by clients all over the country. "Weaving is often and aptly used as a metaphor for life," she says. "Each experience is a thread which, added to the others, helps create the warp and woof of that most unique of fabrics—the self."

Curt Walters, a *plein air* Impressionist painter, works mostly in oil on location and is fiercely committed to preservation of the natural environment. He paints exquisite examples of what he seeks to protect. The Norris Foundation Patron's Award, The Artists of America's People's Choice Award, and the Prix de West Exhibition Buyer's Choice award all stood behind his name in a seven-month period. His works are in many notable corporate and private collections, including those of Mikhail Baryshnikov and Kathy Lee Gifford. A New Mexico native, he moved to Sedona in 1984 to be near his favorite subject, the Grand Canyon. "I am inspired daily by Sedona's vistas, seasons, and varied moods," he says.

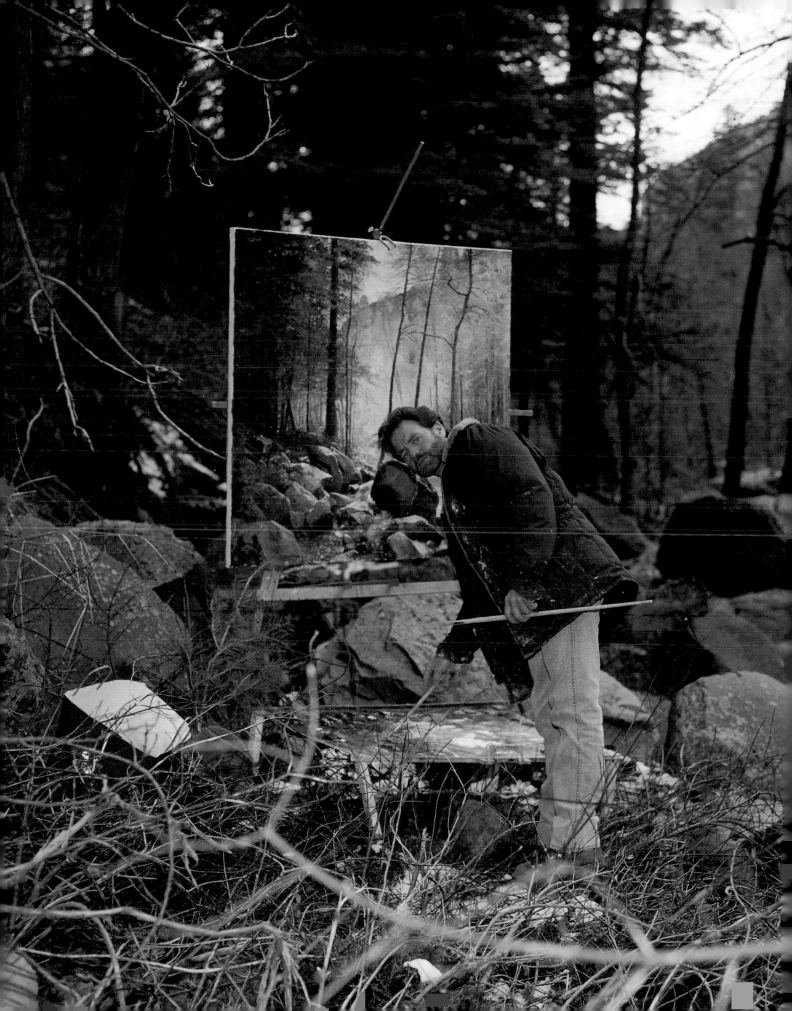

"Come and see what I don't have to say" described Robert Shields's mime performance on the streets of San Francisco in the early 1970s. Shields teamed up with Lorene Yarnell as a mime and in marriage, and the couple had great success. Their television show, *Shields and Yarnell,* was a hit series in the late 1970s. After the partnership ended, Robert's disillusionment with Hollywood sent him questing for a new roost—Sedona. Currently he teams up again with Yarnell for performances with symphonies around the country and is Director of Clowns for the Ringling Bros. Circus. He has transformed his lifelong love for making art into a thriving sculpture, painting, and jewelry design studio. His art, created with meticulous detail and a touch of insanity, makes people smile, and a chance meeting with him can elevate them to a state of joy. "The red rocks make me feel at home because they resemble the clay I have worked with all my life," he says.

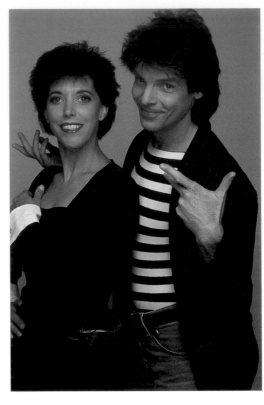

Chris Spheeris is a popular contemporary instrumentalist who has released twelve recordings. He earned a gold record in Greece in 1997. Chris's music is a polyrhythmic, multi-cultural blend with voice, guitar, keyboards, bass, and a variety of percussion instruments from all over the world. "What first attracted me to Sedona," he says, "apart from the surrounding natural beauty, was the tolerance for different beliefs and different ways. With all of the changes I have observed in my eleven years of residence here, this has not changed." Working in the background is Chris's creative partner Robert Cory Bruening.

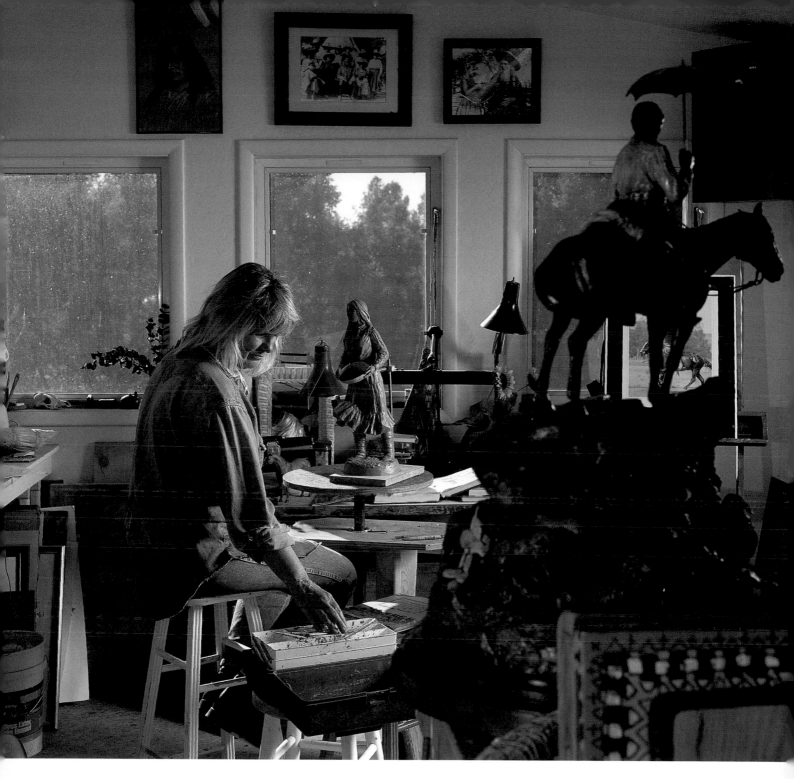

Renowned sculptor Susan Kliewer works in her studio on a clay maquette which will eventually become a bronze sculpture. Her artistic career began as a painter and in 1986 she moved into sculpting. She has since won many awards and was commissioned to create the monumental bronze figure of Sedona Schnebly, Sedona's namesake, permanently displayed outside the Sedona Public Library. Susan works on one of her pieces in a local gallery several days a week in order to demonstrate the transformation of clay into bronze for visitors .

The descendants of the pioneers who still reside in Sedona are aware that their sleepy little town is changing. The Sedona Arts Center, founded in the 1940s, still offers art class-es and live theater. A newer addition is the Sedona Cultural Park, with its annual Sedona International Film Festival and national and international performances. The Park's Georgia Frontiere Performing Arts Pavilion is home to the acclaimed annual Jazz on the Rocks festival. The Sedona Chamber Music Society, flamenco dancers, chant and drum-ming groups—all find followers here. The town is rich in resident writers, designers, musi-cians, dancers, and other expressive professionals, only a few of whom could be represent-ed here.

Susan Kliewer and Jeff Dolan.

Facing: Jim Offield learned needlepoint from both parents at an early age. He says the work is meditative and relaxing, though it wasn't until the early 1980s that he began to spend his free time making rugs, pillows, table covers, and upholstery. Jim has been working on this colorful rug designed by a family friend, Lee Porzio, for three years. It was inspired by the Sedona surround and by Jim and Karin's ranch. The rare silver and leather saddle depicted was made after 1926, an unusual collaboration between saddlemaker D. E. Walker of the Vasalia Stock Saddle Company and renowned silverworker Edward H. Bohlin. The Offields' philanthropic generosity has made a tremendous impact on the community.

Evolving from old-time Western traditions, the relationship between the natural world and the inner self remains a foundation of Sedona life. A holistic attitude is expressed in many ways, from the prevalence of massage therapists to various practices of alternative medicine, including acupuncture, herbal therapy, and meditation, which are woven with traditional medicine in local health facilities.

The unique quality shared by so many in Sedona is their choice to be here. The challenge for us all is to maintain the scenic power and peaceful spirit that drew us, or keeps us, here, even as we add cosmopolitan elements and greater variety to our lives.

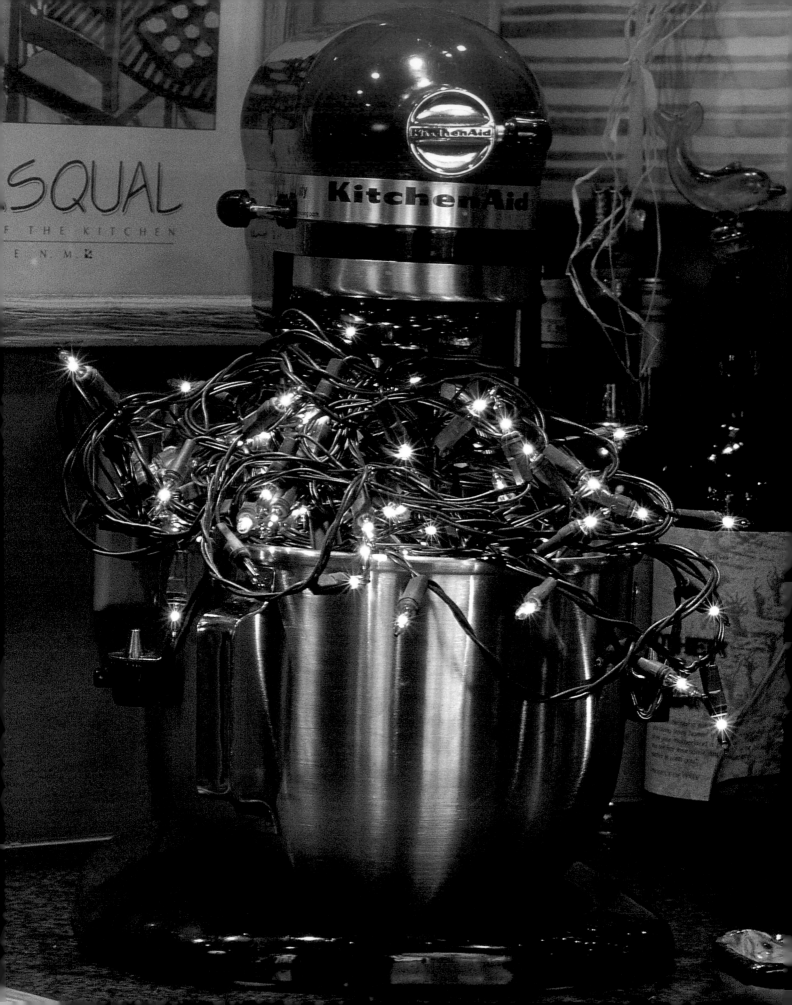

flavors

It is not only the rugged tablelands at the base of the wild red rocks that nurtures people in Sedona, but the experience of another kind of table, the one we gather around to share our lives, tell our stories, break bread together for the nourishment of body and soul. Subtle or spicy, sassy Southwest flavors enhance the tastiness of local fare. The aroma of simmering tomatillos, roasting poblanos, black beans, garlic, and cilantro, alongside steaming corn tortillas, conjures up a sensual feast. The oldest cooking method, used by both ancient cliff dwellers and early-day cowboys, is open-fire cooking. We still relish the smoky perfume of dinner sizzling on the grill as the pleasant pastime of cooking and dining outdoors, surrounded by soaring red rocks, adds extra flavor to the casual lifestyle of present-day Sedona. Locally harvested vegetables, chiles, piñon nuts, apples, and herbs from the kitchen garden all enrich our tables and our lives.

With the diversity of the population comes diversity of palate, and you will find eating experiences ranging from Japanese soba to Thai curries in local restaurants. In the homes of friends, you may be treated to meals in which people express a part of themselves developed in their "other lives"—before they came to live here—through the sharing of favorite family and ethnic dishes. In the spirit of this sharing, we present a collection of recipes that feature regional ingredients or in other ways capture the savor of our area. Here's to nourishing both body and soul!

Antique silver napkin rings, collected over many years, catch the sunlight. They promise that even when friends and family are missing from our tables, they remain part of an unbroken circle.

Appetizers and First Courses

TOMATO TEQUILA SOUP

Fresh cilantro, a dark green annual herb with lacy leaves, adds characteristic flavor and aroma to Southwest recipes. It grows well in Sedona gardens during the cool months. As the Sonoran summer heats up, it tends to bolt, but it will self-sow in a friendly spot. Serves 4

3 tablespoons unsalted butter
1 medium onion, chopped
2 garlic cloves, minced
2 cups vegetable or chicken stock
1/2 cup good quality tequila
8 ripe tomatoes, seeded and chopped
1/4 cup chopped cilantro
1/4 cup chopped parsley
1 teaspoon cayenne pepper
 salt and freshly ground pepper, to taste
 Garnish: sour cream, limes, sweet red pepper

In a heavy saucepan over medium heat, melt the butter. Add the onion and garlic, and sauté 5 minutes. Add tequila and stock and bring to a boil. Reduce heat and simmer until reduced by half, approximately 10 minutes. Reduce heat to low. Add the tomatoes and cook 25 minutes, stir-ring occasionally. Transfer to a food processor and purée until smooth. Add cayenne, cilantro, parsley, salt, and pepper to the purée and stir to blend. Serve cold, garnished with sour cream, lime slices, and chopped sweet red pepper. —JOANNA DEAN

SUMMER TOMATO SAMPLER WITH CUMIN VINAIGRETTE AND TOASTED PINE NUTS

Pine nuts are gathered from the nut-bearing cones of piñon trees, which grow throughout the high country of Arizona. Pueblo tribes traditionally harvest the nutritious kernels. Toast them carefully, as their high oil content makes them vulnerable to burning. Serves 8

3/4 cup pine nuts
1/4 cup balsamic vinegar
3/4 cup good quality olive oil
1 teaspoon ground cumin
1 teaspoon freshly ground pepper
 salt to taste
4 Roma tomatoes
2 Big Boy tomatoes
1 Beefsteak tomato
16 Yellow Pear tomatoes
1/2 pint Red Currant tomatoes
1 tablespoon chopped fresh basil
1 tablespoon chopped fresh thyme

Toast the pine nuts on a baking sheet at 350° until they begin to turn golden. Set aside. Make the Cumin Vinaigrette by whisking together the vinegar, oil, cumin, and black pepper. Add salt to taste. Wash and slice the large tomatoes, leaving the smaller ones whole. Arrange tomatoes on a platter so that they complement each other in shape and color. Drizzle Vinaigrette over the tomatoes and sprinkle with pine nuts. Garnish with chopped fresh herbs. —JOANNA DEAN

PICANTE PEANUTS

Chiles add the fire to regional recipes and they come in many colors, sizes, and degree of hotness. Ask your produce supplier for advice when in doubt. Makes 7 cups

2 pounds salted peanuts
2 tablespoons vegetable or peanut oil
20 small dried red chiles, crushed
4 or 5 cloves of garlic, pressed or minced
1 teaspoon coarse salt
1 teaspoon cayenne pepper

Heat the oil in a wok or large skillet; add red chiles and garlic and toss until garlic turns light brown (be careful of the fumes). Add peanuts and lower heat. Cook, stirring often, 5 minutes, or until nuts are light brown. Sprinkle with coarse salt and cayenne pepper. Mix well and cool. —
JOANNE GOLDWATER

CASA DE COBLE SHRIMP GUACAMOLE

Shrimp shipped to the Southwest from Guaymas, Mexico, is readily available in our markets. Combined with avocados, it gives a new twist to a traditional Mexican dish.

3 to 4 avocados, peeled, seeded, and mashed
1 tablespoon fresh lime juice
6 ounces feta cheese, crumbled
1/4-1/2 pound cleaned, cooked, and chopped shrimp
1/4 cup minced, fresh cilantro
1 minced and seeded fresh jalapeño chile
1 medium red onion, chopped fine
2 tablespoons sour cream
 Tabasco sauce to taste
 salt and pepper to taste

Mix all these ingredients together in a bowl. Serve with round tortilla chips. Use a spoon to serve as mixture is thick. —CONNIE COBLE

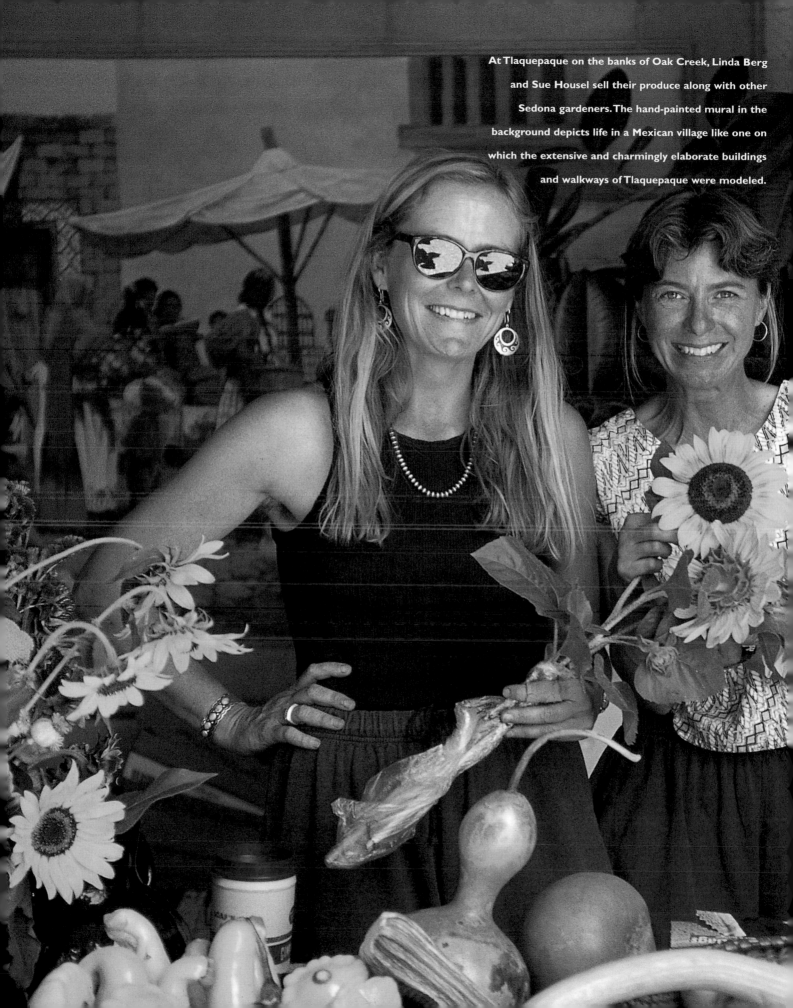

At Tlaquepaque on the banks of Oak Creek, Linda Berg and Sue Housel sell their produce along with other Sedona gardeners. The hand-painted mural in the background depicts life in a Mexican village like one on which the extensive and charmingly elaborate buildings and walkways of Tlaquepaque were modeled.

TRI-COLORED PEPPER BRUSCHETTA

Farmers' market bounties of garden variety peppers and fresh basil give this appetizer a dazzling flavor in summer. As a variation, substitute sliced flavorful tomatoes for the peppers, or use a combination of tomatoes and peppers. Serves 6 to 8

1 shallot, diced

2 cloves garlic, pressed or crushed and minced

3 medium peppers (red, yellow, and green) seeded and julienned

2 tablespoons olive oil
 freshly ground pepper and salt to taste

8 slices crusty French baguette, cut 1/2 inch thick

8 ounces fresh goat cheese, imported or domestic
 thinly sliced basil leaves for garnish

Preheat broiler. Place olive oil in a medium sauté pan over moderately high heat. Add shallot and peppers and gently cook until peppers are softened and lightly browned. Lower heat and add the garlic, pepper, and salt. Cook 2 minutes. Do not allow garlic to brown.

Toast bread slices in a broiler until lightly browned. Turn them and toast the other side. While they are still warm, spread each slice with goat cheese. Spoon about 1 tablespoon pepper mixture over the cheese and garnish with fresh basil. Serve immediately.

—JOANNA DEAN

JALAPEÑO-MARINATED VEGETABLES

This colorful South of the Border dish can be served as a spread with toasted baguettes, or as a salad. It also makes an excellent side dish with grilled meats.

15 fresh jalapeño chiles, seeded and slivered

1 onion, sliced

8 cloves garlic, finely diced

4 zucchini, sliced into julienne strips

1 jar of marinated, sliced cactus pads or a fresh cactus pad, julienned and cooked in boiling salted water 15 minutes, drained

6 carrots, peeled and sliced diagonally into quarter-inch slices, parboiled until crisp-tender, drained

1 cauliflower, divided into small flowerettes, parboiled until crisp-tender, drained

1 teaspoon dried oregano or 1-1/2 tablespoons fresh

1 teaspoon dried thyme or 1-1/2 tablespoons fresh

1 teaspoon dried marjoram

1 teaspoon salt

2 bay leaves

2 cups white wine vinegar

2 tablespoons olive oil

1 chicken bouillon cube or packet

In a medium skillet, heat the olive oil and sauté the prepared jalapeños, onion, and garlic over low heat until soft, about 10 minutes. Add drained cactus to the jalapeño mixture and cook an additional 5 minutes. Add zucchini and cook until soft, 3 minutes. Add carrots and cauliflower. Add seasonings, vinegar, oil, and bouillon cube. Bring to a boil , lower heat, and simmer 10 minutes. Cool to room temperature, then chill if not to be eaten immediately. Keeps up to three days in the refrigerator.

—GLORIA GUADARRAMA

Salads

BLUE CORN CHICKEN SALAD

For hundreds of years the Hopi have been grow-ing blue corn and using it for sacred ceremonies. It is considered to have higher nutritional value and flavor than other corn varieties. Serves 2

12 ounces chicken breast strips or chicken
 tender pieces
 salt and pepper
1/4 cup flour
1/2 cup buttermilk
1 cup blue cornmeal, seasoned with salt and
 pepper

4 cups lettuce
1/2 ounces ranch style dressing
1/4 teaspoon cayenne pepper
1/2 cup canola or olive oil
1 large onion
 Garnishes: Diced tomatoes, thinly sliced
 yellow and red bell pepper strips, thinly
 sliced carrot strips, sliced mushrooms

Lightly season chicken strips with salt and pepper. Dredge them in flour, shaking off excess. Dip them in the buttermilk, then roll them in the blue cornmeal, back in the buttermilk again, and give a final roll in the blue cornmeal. Set aside.

Cut onion into round slices and separate them into individual rings. Roll them in the flour, then dip them in the buttermilk, sprinkle with salt and pepper and then roll them in the flour again. Set aside.

Heat a large skillet over medium high heat. Add the oil and heat until a pinch of flour sizzles in it. Add all the chicken pieces and cook 3 minutes on each side. Place cooked chicken on paper towel to dry and then keep warm in low heated oven. Next, cook the onion rings in the same oil until crispy.

Drain on paper towel and keep warm with chicken.

Mix the ranch style dressing with the cayenne pepper. Place the lettuce in a large salad bowl and toss with the dressing. Place lettuce on 2 dinner plates and lay the chicken strips around the rims of the plates. Garnish with the tomatoes, bell peppers, and mushrooms. Top with the onion rings and serve. —KURT JACOBSEN, MAIN STREET CAFE

ROASTED POTATO SALAD

This is a great dish for picnics or backyard par-ties. It is best served at room temperature. Roasting the poblano chiles brings out an earthy smoke flavor. Serves 8 to 10

4 medium red skinned potatoes
2 medium onions
4 stalks of celery
1/3 cup olive oil (use part for roasting pota-
 toes, a little for cooking onions)
 salt and pepper
2 cups Poblano Remoulade

Preheat oven to 350°. Cut potatoes into large bite-sized pieces. Place on a sheet pan with sides. Salt and pepper to taste. Toss with a generous part of the olive oil. Roast until tender and golden brown (about 30 minutes), turning with a spatula halfway through. Let cool to just above room tem-perature, still slightly warm. While the

potatoes are cooking, cut onions into thick slivers. In about 1 tablespoon of oil, sauté onions until the edges start to blacken. They should not be soft and carmelized. Remove from the pan and let cool. Cut the celery into a medium fine dice. Mix all the ingredients with the Poblano Remoulade and serve. —SUSAN AND JOHN ETTLINGER

POBLANO REMOULADE

When summer is over, brilliant red poblano chiles are hung in strands to dry in Arizona. Used whole or ground, they are found on some Southwest tables at nearly every meal. Use this sauce for roasted potato salad, as a spread on turkey and roast beef sandwiches, or as a basting sauce for grilled meats, especially lamb. Makes 2 to 3 cups

1	cup mayonnaise
6	poblano chiles
2	red bell peppers
1	medium yellow onion
1	serrano pepper
3	tablespoons finely minced parsley
1	tablespoon olive oil
2	tablespoons lime juice
1	teaspoon ground cumin
1	teaspoon Tabasco sauce
	salt and pepper

Preheat a grill or oven to 500°. Coat the whole poblanos and red peppers with the olive oil. Place in the hot oven on sheet pan or directly on the grill, and roast them until their skins are shiny gray-black. They will need to be rotated occasionally. Once the pepper skins are darkened, remove them and place in a bowl. Cover with a lid or plastic wrap. Let them steam and cool. Once cool, the skins, seeds and cores may be removed easily. Finely mince the peppers, the onion, and seeded serrano pepper.

You may want to use rubber gloves for this as the spice is quite strong. Add these ingredients and the remaining ingredients to the mayonnaise in a mixing bowl. Mix well and let stand, covered, in the refrigerator overnight. Can be kept under refrigeration for up to a week. —SUSAN AND JOHN ETTLINGER

SOUTHWESTERN CAESER SALAD

Roasted and salted pumpkin seeds, called pepitas in Spanish, make a tasty snack. Corn tortillas are the "bread of Mexico." Serves 8

2	teaspoons chopped garlic
2	teaspoons anchovy paste
1	ounce Egg Beaters or one egg
2	teaspoons Dijon mustard
3/4	cup olive oil
1/8	teaspoon Tabasco sauce
3/4	cup freshly grated Parmesan cheese
1	teaspoon Worcestershire sauce
	freshly ground pepper and salt to taste
1	tablespoon lemon juice
1/4	cup balsamic vinegar
1/2	cup pumpkin seeds
8	corn tortillas
	salt and chile powder to taste
	non-stick vegetable spray
2	heads Romaine lettuce

To make the dressing: Purée garlic, anchovy, egg, and mustard in food processor. Add oil, Tabasco, Worcestershire, pepper, salt, lemon juice, and vinegar. Process one to two minutes until well combined.

Place pumpkin seeds on a baking sheet and roast in oven at 350° for 10 minutes, or until toasted.

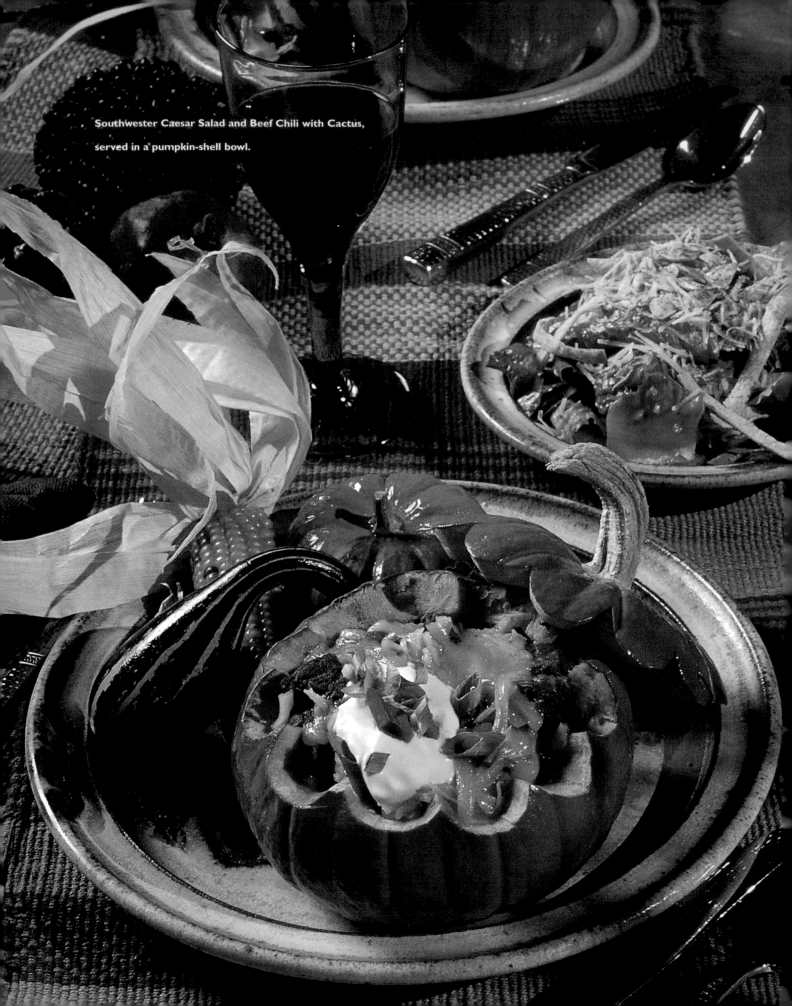

Southwester Caesar Salad and Beef Chili with Cactus, served in a pumpkin-shell bowl.

Cut tortillas into 1/4-inch by 2-inch strips, place on cookie sheet and toast in oven at 350° for 10 minutes. Spray the toasted tortilla strips with non-stick vegetable spray and dust with salt and chile powder. Wash and dry lettuce, and tear into bite-size pieces. Place lettuce in a large salad bowl. Toss with dressing until combined. Sprinkle with freshly grated parmesan, pumpkin seeds, and tortilla strips. —CARLA GASPER, OAXACA RESTAURANT

Entrées, Side Dishes, and Breads

BEEF CHILI WITH CACTUS

Edible prickly pear cactus pads are available in many produce departments or can be ordered from your grocer. Masa harina (a corn flour) is also readily available at the grocery. Serves 6

4 tablespoons vegetable oil, divided
2 pounds round steak, cut into 1/4-inch cubes
1 cup chopped onions
1 cup chopped green pepper
2 cloves garlic, chopped
1 tablespoon ground cumin
1/2 teaspoon cayenne pepper
1/4 teaspoon dried oregano
1 teaspoon crushed dried red chiles
1 poblano chile, roasted, peeled, seeded, and diced
2 Anaheim chiles, roasted, peeled, seeded, and diced
2 serrano chiles, seeded and diced
1 can (28 ounces) tomatoes
1 cup tomato sauce
1 cup beer
1/2 cup nopalitos (cactus pads) julienned and chopped
 salt and freshly ground pepper to taste

1/4 cup masa harina
 For garnish: Sour cream, shredded cheese, and chopped green onions

In a large skillet, heat 2 tablespoons of the vegetable oil over medium high heat. Add half the round steak pieces; brown; remove and set aside. Repeat with remaining steak. In the same skillet, add the remaining vegetable oil and sauté onion and green pepper until soft and lightly browned, about 10 minutes. Add garlic, cumin, cayenne pepper, oregano, and crushed dried red chiles. Cook, stirring, for 2 minutes, or until flavors are well blended.

Put browned meat and onion mixture in a large pot. Add chiles, tomatoes, tomato sauce, beer, and nopalitos. Cook, uncovered, over low heat for 1 hour. Sprinkle masa harina over chili and stir until thoroughly mixed. Cover pot and simmer gently for 3 hours.

Divide chili among bowls; pass sour cream, chopped green onion, and shredded cheese for garnish. —BARBARA POOL FENZL

JUNIPER BERRY MARINADE

Berries gathered fresh from juniper trees in the Sedona area have a light and delicate flavor. If using purchased berries, cut the quantity in half, as they are more pungent. Makes three-fourths cup

1 teaspoon ground juniper berries
1 teaspoon dried sage leaves, rubbed
1 chopped shallot
3 cloves garlic, minced
1/4 cup of balsamic vinegar
1/4 cup of olive oil
 sprig of parsley, 1 teaspoon chopped
 sprig of thyme, 1 teaspoon chopped

Juniper berries
on the branch
in Sedona. The
ripe berries
are used by
local cooks
and are also a
favorite snack
for coyotes.

Mix all the ingredients in a jar or lidded container and shake vigorously. Let stand 1 hour at room temperature. Pour over the meat of your choice: lamb, steak, wild game, or portabello mushrooms and grill to your liking. —KURT JACOBSEN

SOURDOUGH BISCUITS

Cow camp cooks used sourdough recipes because the starter traveled well without refrigeration. These biscuits were served to film crews during the making of western movies at the Bradshaw Ranch near Sedona. Makes about 16 biscuits

Starter:

2 cups flour
2 tablespoons sugar
1 package active dry yeast
2 cups warm water
1/2 teaspoon salt

Biscuits:

1-1/2 cups flour
2 teaspoons baking powder
1/2 teaspoon baking soda
1 teaspoon salt
1/4 cup vegetable oil
1 cup sourdough starter
1 tablespoon unsalted butter, melted

For the starter: Two or three days before making biscuits, make sourdough starter. Mix all starter ingredients in a large bowl; loosely cover and refrigerate 2 to 3 days, stirring occasionally. Remove amount needed; replenish with equal portions of flour and water. The starter will keep indefinitely, refrigerated, as long as it is replenished each time it is used.

For the biscuits: In a large bowl, sift dry ingredients together. Stir in the oil and sourdough starter and mix until smooth. Knead dough on a lightly floured board until it is smooth and elastic. With a rolling pin, roll the dough to 1/2-inch thickness. Using a 2-inch round cutter, cut dough into biscuits and place on a greased baking sheet. Brush lightly with melted butter and allow to rise in a warm place for 45 minutes to an hour. Preheat oven to 425° and bake 20 minutes or until lightly browned.

—BARBARA POOL FENZL

ROSEMARY·CHEDDAR·WALNUT BISCUITS

This recipe was developed to celebrate the beautiful and aromatic rosemary bushes that grow easily in Sedona gardens. Makes 12 to 16 biscuits

1 packet dry active yeast (2-1/4 teaspoons yeast)
5 tablespoons warm water
3 tablespoons sugar
2/3 cup or slightly less walnut or canola oil
2 cups buttermilk (low-fat is fine) at room temperature

4 to 5 cups unbleached all-purpose flour
5 teaspoons baking powder
1 teaspoon baking soda
2 teaspoons coarse kosher salt

1 cup shredded extra-sharp cheddar cheese
1/2 cup lightly toasted, chopped walnuts (toast in the oven or a toaster oven approximately 10 minutes at 275°; watch carefully to avoid burning)
3 tablespoons fresh snipped rosemary, or to taste

In a medium bowl, dissolve the yeast in the water by stirring. Stir in sugar. Add the buttermilk and set aside.

In a large mixing bowl, combine the flour, baking powder, soda, and salt with a whisk. Add the yeast-buttermilk mixture to the dry ingredients and stir to blend into a stiff dough (do not over-handle or biscuits will be tough). Turn the dough out onto a floured board and knead about ten strokes. Pat back into a ball and allow to rest 30 minutes.

Roll out the dough thickly (about 1 to 1/2 inches thick). Scatter with half the cheese, nuts, and rosemary. Fold over, press, and knead gently to barely incorporate. Roll out again and scatter with the remaining cheese, nuts, and rosemary. Fold and press to incorporate. Roll out a third time.

Cut the dough into large rounds with a coffee cup or biscuit cutter and place on a lightly oiled baking sheet. At this point, you can allow the biscuits to rest again until you are ready to bake them—up to an hour—or bake them immediately.

To bake, place the biscuits in a *cold* oven, then turn the oven on to a temperature of 450°. The biscuits will rise and bake as the oven heats up. They are done in 10 to 15 minutes when they are puffed and golden; begin checking after 8 minutes to be sure they don't burn. —CAROL HARALSON

CANYON STACK SANDWICH

Packed in an ice chest, this is perfect picnic fare! Serves 4

8 slices crusty French bread
1/4 cup good quality olive oil
1/4 cup fresh lemon juice
1 tablespoon Dijon mustard
4 chicken breast halves, skinned and boned
8 thin slices prosciutto
1/2 pound goat cheese, at room temperature
1 head leaf lettuce
1 roasted sweet red pepper
1 Anaheim roasted chile pepper
1/2 cup Calamata olives, pitted and chopped
1/2 cup good quality mayonnaise

Mix oil, lemon juice, and mustard in a small bowl. Salt and pepper chicken generously and add to the bowl. Marinate 1 hour, refrigerated. Grill chicken 7 minutes on each side. Cool. The chicken can be left whole or sliced at an angle.

Heat oven to 400°. Place the peppers on a parchment-lined cookie sheet and roast for 30 minutes or until peppers are blackened and skin is blistered. (Alternatively, you can roast peppers directly over a gas flame, under the broiler, or on a grill.) Place charred peppers in a closed brown paper bag and allow to cool. Peel, seed, and trim the peppers, and cut them into strips. Assemble the sandwich stack in this order: bread, goat cheese, olives, lettuce, chicken, ham, peppers, mayonnaise, and bread. — JOANNA DEAN

ARIZONA RANCH STYLE BEANS

The Goldwater family has played an important part in the state's history. Barry Goldwater was a United States Senator, a presidential candidate, and respected statesman. He is also famous for his photography of the Indian culture and Arizona scenery. Selections from his Southwest collection can be seen at the Heard Museum in Phoenix. This recipe comes from the Goldwater kitchen. 24 servings

2 pounds dried pinto beans
2 chopped onions
2 cloves garlic, minced
2 teaspoons salt
 pepper to taste
1/2 teaspoon cumin seed
4 ounces taco sauce, purchased or home-made
4 ounces mild green chiles, home-roasted or purchased canned, diced
1 twenty-eight-ounce can best-quality tomatoes
 Optional: 1/2 pound browned ground beef or ham bits

Wash beans. In large pot, cover beans with water to 2 inches over top of beans. Bring to a boil and cook 1 hour. Add the rest of ingredients except the cooked meat. Reduce the heat to a simmer and cook 5 hours more. Add meat and heat. —JOANNE GOLDWATER

RED ROCK CORN CHOWDER

Corn is essential to the life of many Southwestern Native American groups. It grows well in the Verde Valley. Serves 8

1 cup diced potatoes
1 cup roasted corn kernels
1 cup diced onion
1/2 cup diced celery
1/2 cup diced carrot
2 strips of bacon in 1/2-inch pieces
2 chicken bouillon cubes
1 cup Chablis wine
1/4 cup fresh chopped garlic

1/2 **cup roasted, peeled and diced poblano**
 chiles (may use canned green chiles or
 canned poblano chiles)
3 **tablespoons curry powder**
1 **tablespoon cayenne powder**
1 **quart water**
1 **quart heavy cream (or milk for lighter**
 soup)
3 **tablespoons butter**
3 **tablespoons flour**
 salt and white pepper

In a 4-quart soup pot, place the potatoes, corn, onion, celery, carrots, bacon, bouillon, wine, garlic, curry, and cayenne. Bring to a boil and cover, lowering the heat to a simmer, and cook until onions are translucent.

Add water and cream and bring to a boil. Cook until potatoes are just tender. In a separate pan, melt butter slowly, add flour, and simmer one minute, constantly stirring. Add to chowder and simmer 5 minutes, stirring regularly. Finish with salt and white pepper to taste. —KURT JACOBSEN

BLUE CORN POSOLE WITH CHICKEN

Almost every Pueblo tribe in the Southwest region uses hominy as a base for some Native American dishes such as this rustic stew. Serves 8

2 **pounds diced raw skinless chicken breasts**
1-1/2 **cups chopped onions**
2 **teaspoons chopped garlic**
4 **teaspoons olive oil**
7-1/2 **cups cooked blue corn hominy (may be**
 canned)
7-1/2 **cups chicken broth**
2 **teaspoons chili powder**
3 **teaspoons dried oregano**
4 **bay leaves**
1 **teaspoon ground cumin**
1/2 **red pepper, chopped**
1/2 **green pepper, chopped**
1/4 **cup chopped cilantro**
1 **thinly sliced lime**

Sauté chicken in olive oil in skillet over medium high heat till still moist and tender but no longer translucent, about 10 minutes. Add onion, garlic, red and green pepper, and sauté 5 minutes more. Combine hominy, spices, chicken mixture, and chicken broth in a saucepan and simmer for 1 hour. Remove bay leaves, and garnish with chopped cilantro and sliced lime. —CARLA GASPER

CHICKEN TAMALES WITH TOMATILLO SAUCE

Freshly steamed tamales are irresistible. So are tamales rewarmed for breakfast the next day. You can make these ahead and freeze them, before or after steaming. Serves 8 to 10

4 to 6 chicken breasts
 salt and cracked pepper
1 teaspoon crumbled dried sage
1 small dried hot red chile, crumbled
 water or chicken broth for braising
3 whole cloves garlic

10 tomatillos
1 to 2 jalapeño chiles
3 large cloves garlic
1 tablespoon vegetable oil
 kosher salt to taste

5 pounds prepared masa
3 teaspoons kosher salt
1-1/2 teaspoons baking powder
1/2 pound butter
1/3 to 1/2 cup canola oil
1-1/2 cups chicken broth

approximately 30 dried corn husks (sold in packets in the Hispanic section of the supermarket), soaked in hot water for 20 minutes and drained

Cook the chicken: Place the chicken in a heavy saucepan, season with salt and pepper, and add chile plus chicken broth or water to barely cover. Simmer until chicken is done but still moist. Allow it to cool in the cooking liquid. When cool enough to handle, strip from bone and shred. Set aside. You can reserve this cooking liquid and use it to make the tamale dough, especially if you used broth rather than water.

To make the tomatillo sauce: Husk and wash the tomatillos. Place tomatillos in a heavy saucepan with stemmed whole jalapeños and water to cover. Boil until the tomatillos are soft, about 10 minutes. Allow to cool slightly, then remove the tomatillos to a blender or food processor, reserving the cooking liquid. Add the garlic cloves and blend or process until the tomatillos are well crushed. Add a little of the cooking water if necessary. The sauce should retain some chunky consistency so do not purée. Return the sauce to the saucepan with oil and salt and cook, stirring, to reduce somewhat. Be somewhat generous with salt, as the tamale dough tends to absorb flavors and the tamales will taste flat if not sufficiently seasoned. Set the sauce aside.

To make the tamale dough: Combine the masa, salt, baking powder, butter, and oil in an electric mixer bowl. You may need to do this in two batches, depending on the size of your mixer. Beat till very fluffy, adding broth as you go. To test whether the dough is fluffy enough, drop a pinch into a glass of cold water. If it immediately bobs to the top, the dough is ready; if it sinks, beat some more. When ready, the dough should be light, moist, and creamy, similar to the consistency of whipped butter.

To assemble the tamales: Place one wide or two narrower cornhusks in the palm of your hand. Place about 2 large tablespoons tamale dough in the center of the husks and smear to spread. Add 2-3 heaping tablespoons shredded chicken and a large dollop of sauce. Fold to close, nudging the dough toward the center to encourage it to mostly enclose the filling. Wrap to close and tie shut with strips of cornhusk.

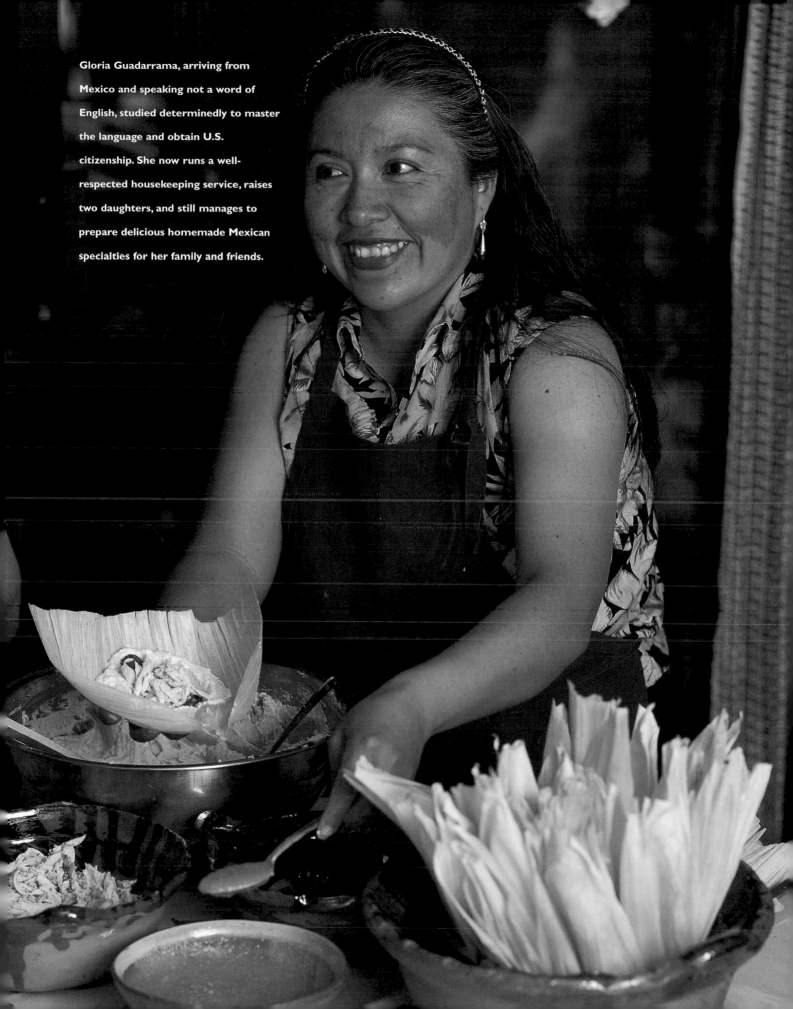

Gloria Guadarrama, arriving from Mexico and speaking not a word of English, studied determinedly to master the language and obtain U.S. citizenship. She now runs a well-respected housekeeping service, raises two daughters, and still manages to prepare delicious homemade Mexican specialties for her family and friends.

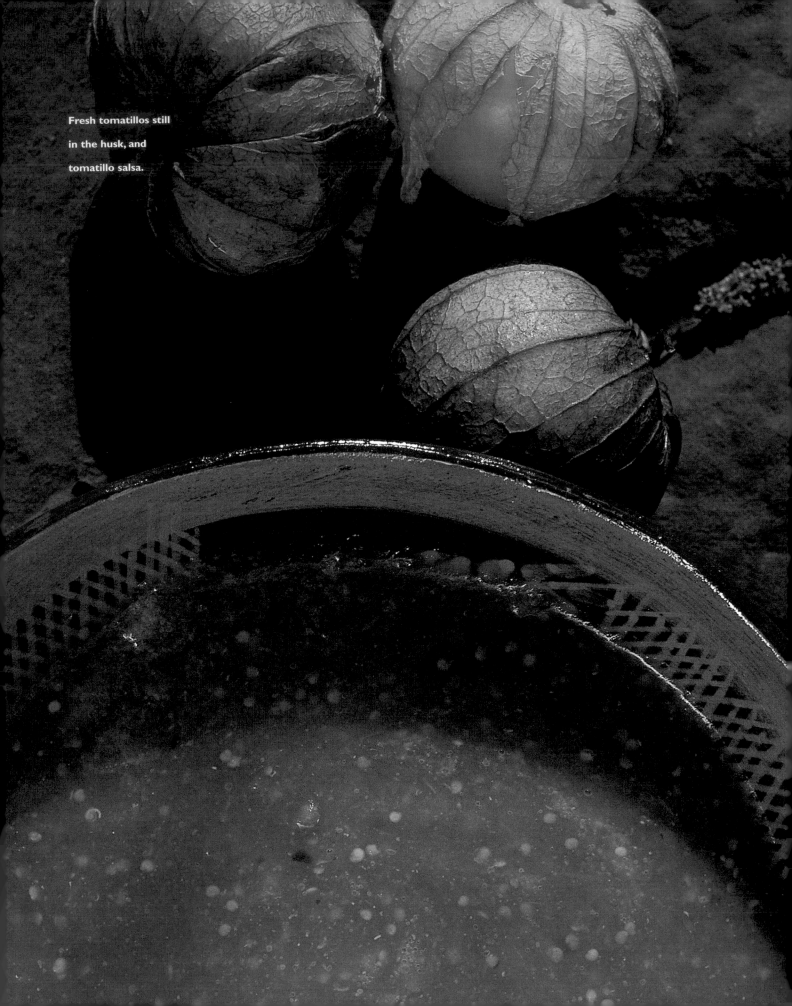

Fresh tomatillos still
in the husk, and
tomatillo salsa.

Steam the tamales: Place as many tamales as will fit into the top of a large steamer basket lined with cornhusks, cover, and place over boiling water. Steam about 1 to 1/2 hours. To test for doneness, remove one tamale from the steamer and gently pull back the cornhusk. If the dough holds together and does not adhere to the husk, the tamales are done. Do not overcook, or tamales will be dry. Serve with additional tomatillo sauce or with other salsas, and with small bowls of crumbled Mexican white cheese or feta, chopped onion, and fresh cilantro, if desired. —GLORIA GUADARRAMA

SHRIMP TAMALES WITH SUN-DRIED TOMATOES AND ENCHILADA SAUCE

Tamales are considered fiesta food in Mexico, and are traditionally made at Christmas in the Southwest. Packets of dried corn husks are available in many supermarkets. Masa—ground limed hominy—is also widely available. It resembles a grainy, golden dough and is frequently sold in four-pound packages in the meat section of Southwestern grocery stores. Masa is limestone-soaked and finely ground cooked hominy corn kernels. The sauce served with these tamales makes a terrific enchilada sauce, and complements quesadillas, egg dishes, and other Southwestern fare. Serves 6 to 8

1/2 cup butter
2 cups corn masa
2 teaspoons chili powder
2 teaspoons salt
1/2 teaspoon baking powder
1 cup chicken broth
3 ounces sun-dried tomatoes

32 raw jumbo shrimp
18 dried corn husks
1/4 cup olive oil
2 teaspoons chopped garlic
1/2 cup pure ground New Mexican red chile
2 tablespoons flour
1/2 teaspoon ground cumin or more to taste
1/2 teaspoon coriander seeds, ground finely
2 cups chicken broth, heated

To make the tamale dough: Whip butter using a food processor or electric mixer until light and fluffy. Add corn masa, chili powder, salt and baking powder, and process until combined. Add the chicken broth and process on high until thoroughly mixed. To test whether tamale dough is light enough, drop a pinch into a glass of cold water. If it floats to the top, it is ready to use. Reconstitute the sun-dried tomatoes with water until soft. Drain and finely chop. Add the tomatoes to the masa mixture and stir by hand. Set aside.

Place the dry corn husks in water for 20 minutes to soften. Remove and drain. Hold one husk flattened in the palm of your hand, and place 2 tablespoons of tamale dough in the center of it, flattening with

the back of a spoon. Place 2 jumbo raw shrimp in the center, and close the corn husk by folding in the sides to create a cylinder. Twist the ends of the rolled-up husk and tie them shut with strips of corn husk.

Place the tamales in a steamer, and steam on low for approximately 1 hour and 15 minutes. To test for doneness, remove one tamale and partially unroll. If the tamale dough comes away from the husk, tamales are done. (Overcooking will make them dry.) While steaming, prepare the sauce.

To make the Enchilada Sauce: Place oil in sauce pan and heat until hot. Add garlic and sauté 5 minutes. Add flour and whisk to blend. Add all dry spices, whisking into a paste. Add one-fourth cup chicken broth. For a smooth sauce, whirl the mixture in a blender or processor and return it to the pot. For chunkier sauce, omit this step. Add remainder of broth and cook over low heat, stirring frequently, as sauce thickens. Add salt to taste.

Serve the tamales on a platter still in their husks and pass the sauce separately. Provide an extra bowl to place the husks in.

—CARLA GASPER

FRESH HOMEMADE FLOUR TORTILLAS

In northern Mexico, the wheat-growing region, flour tortillas are as common as corn ones. They are usually made a bit larger than corn tortillas. Mexican families make these daily as this "bread of Mexico" is a staple at meals.

2 cups all-purpose flour
1 teaspoon salt
1/2 teaspoon baking powder
1/2 cup lard or shortening
1/2 cup warm water

Mix together the flour, salt, and baking powder. Cut in the shortening and mix well. Add the water gradually, working it in to make a stiff dough. Knead until the dough is springy. Divide into balls of equal size, lightly coat each ball with butter, oil, or lard (optional), cover the bowlful of balls, and allow them to rest 30 minutes.

Heat a heavy frying pan or griddle over medium-high heat. Lightly flour a work surface. Use a rolling pin to roll out one ball of dough to a diameter of about 8 inches. Roll backwards once and forward once.

Pick up the rolled out tortilla and slap it back and forth, stretching it with the fingers to make it a little thinner and to even up the edges.

Lay the tortilla on the hot ungreased cooking surface. Bake until speckled with light brown, about 1-1/2 to 2 minutes. Turn and bake the other side about the same amount of time, watching for brown speckles. Remove from griddle.

Serve hot immediately, with salsas and cheese, or keep warm in a covered basket. Tortillas keep under refrigeration for a few days and can be re-toasted on a griddle or in a toaster oven, or filled with cheese, salsa, grilled vegetables, or fresh herbs. Fold the filled tortilla into a half moon, and cook in a heavy skillet, turning once or twice, until the cheese melts and the tortilla is heated through. —MARIA DELGADO

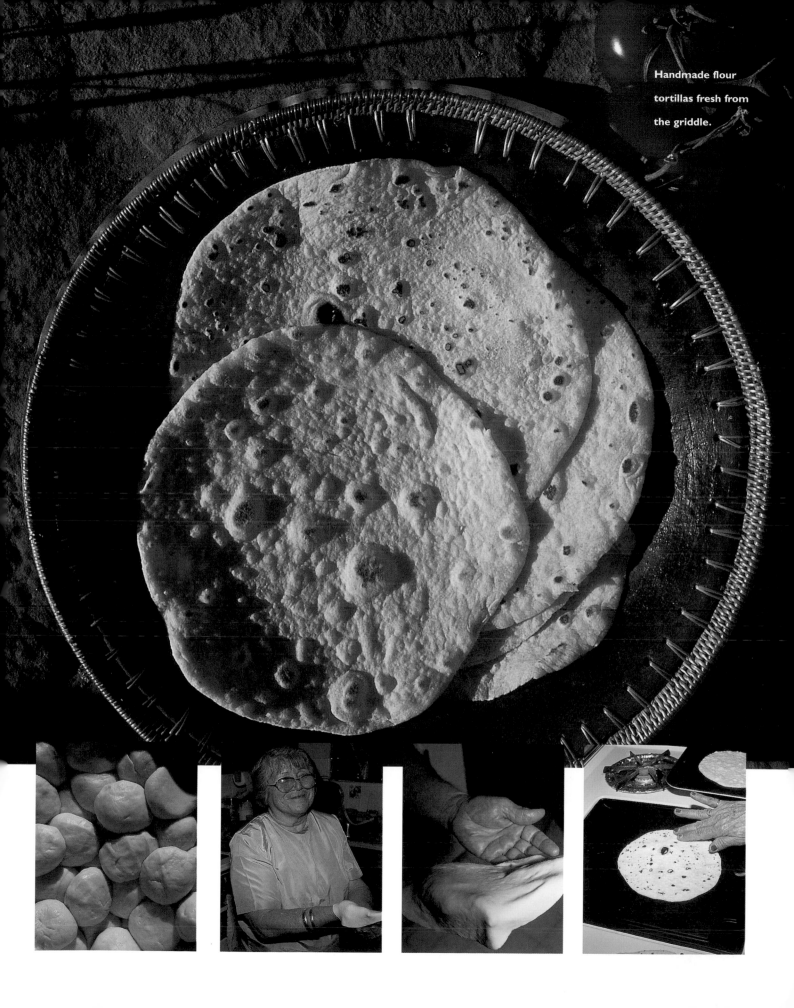

Handmade flour
tortillas fresh from
the griddle.

EL ROJO RIBS

The aroma of barbecued ribs conjures up an image of the Old West and hungry cowboys waiting for their grub.

4 racks of baby back ribs
 salt and pepper to taste
2 thinly sliced lemons
1 thinly sliced onion
12 ounces **Goldwater's Bisbee Barbecue Sauce**, or homemade barbecue sauce

Arrange ribs in a roasting pan or cookie sheet with sides and sprinkle with salt and pepper. Lay lemon and onion slices over ribs. Cover with foil. Bake in 350 degree oven for 1 hour. Remove from oven and pour off the melted fat. Add some water to pan, cover again and steam for another 1/2 hour.

Prepare grill. Baste the ribs generously with barbecue sauce. Grill the ribs for about 1/2 hour, basting frequently with sauce. (Alternatively, finish roasting in the oven.) —JOANNE GOLDWATER

POBLANO-BLACK BEAN SALSA

This condiment can be used to complement foods such as baked potatoes, fish, steaks, and eggs or as a topping for tortilla chips.

2 cups cooked black beans or canned cooked black beans, drained
1 garlic clove, minced
1 tablespoon pure ground chile
1/2 teaspoon ground cumin
1/2 cup chopped fresh cilantro
1/2 cup each: diced green, red, yellow bell peppers
1 poblano chile, roasted, peeled and minced
 juice of one-half fresh lime

If using canned beans, rinse and drain. Mix beans with all additional ingredients. Serve with tortilla chips or as a topping for grilled chicken or fish. —CAROL HARALSON

SEDONA GRILLED CORN WITH FRESH HERBS

Harvested in summer, fresh corn should be eaten as soon as possible to retain the natural sugar. Verde Valley corn is sold by the truckload in August from a farmstand. Plump kernels signal freshness. Serves 6

6 fresh ears of corn, in the husk
1/2 cup butter (1 stick), softened at room temperature
1/4 cup finely chopped chives
1/4 cup finely chopped cilantro
2 tablespoons finely chopped fresh rosemary
1/8 teaspoon pepper flakes
1/8 teaspoon chile powder
1/2 teaspoon kosher salt
1/2 teaspoon freshly cracked black pepper
 kitchen string to tie husks

Pull husks down from corn leaving the husks attached at the bottom. Remove the silk from the corn. In a small bowl, combine the butter, chives, cilantro, rosemary, pepper flakes, chile powder, salt and pepper until well blended. Spread the butter liberally all over the corn. Pull husks neatly up over the corn and tie the husks to the corn with butcher string. You may need to make several ties.

Preheat grill to medium-high heat. Place corn on the grill and cook for 30 to 40 minutes, turning occasionally. Husks should be slightly blackened. Serve corn in the husks or remove the husks before serving. —KAREN RAMBO

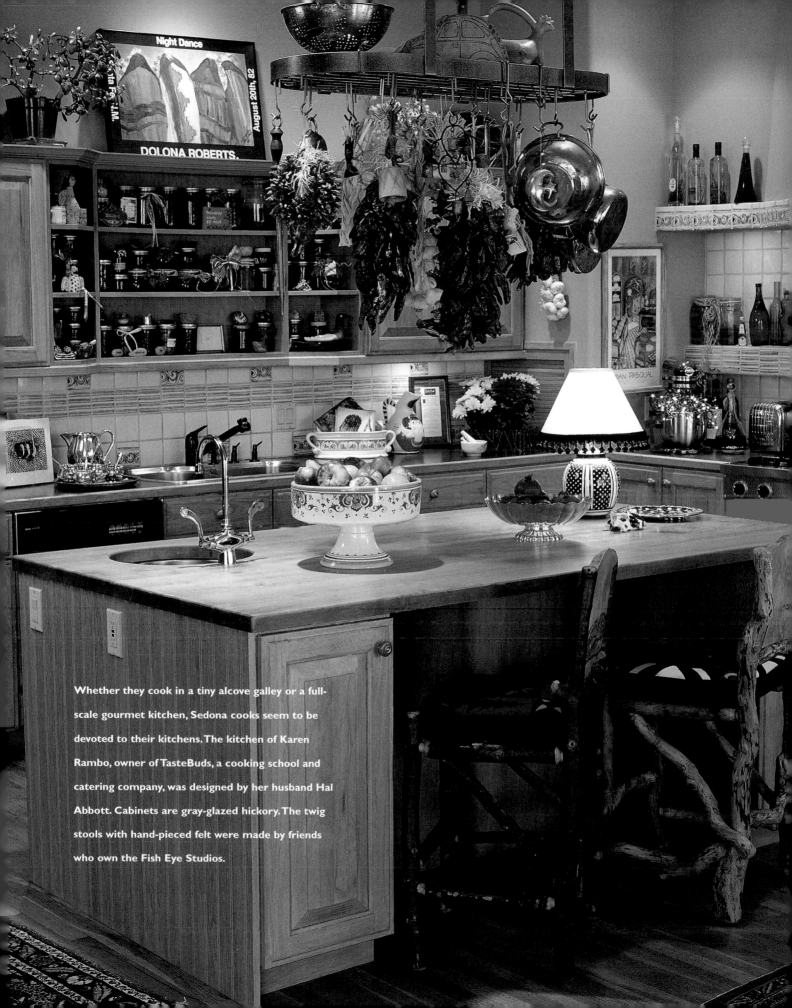

Whether they cook in a tiny alcove galley or a full-scale gourmet kitchen, Sedona cooks seem to be devoted to their kitchens. The kitchen of Karen Rambo, owner of TasteBuds, a cooking school and catering company, was designed by her husband Hal Abbott. Cabinets are gray-glazed hickory. The twig stools with hand-pieced felt were made by friends who own the Fish Eye Studios.

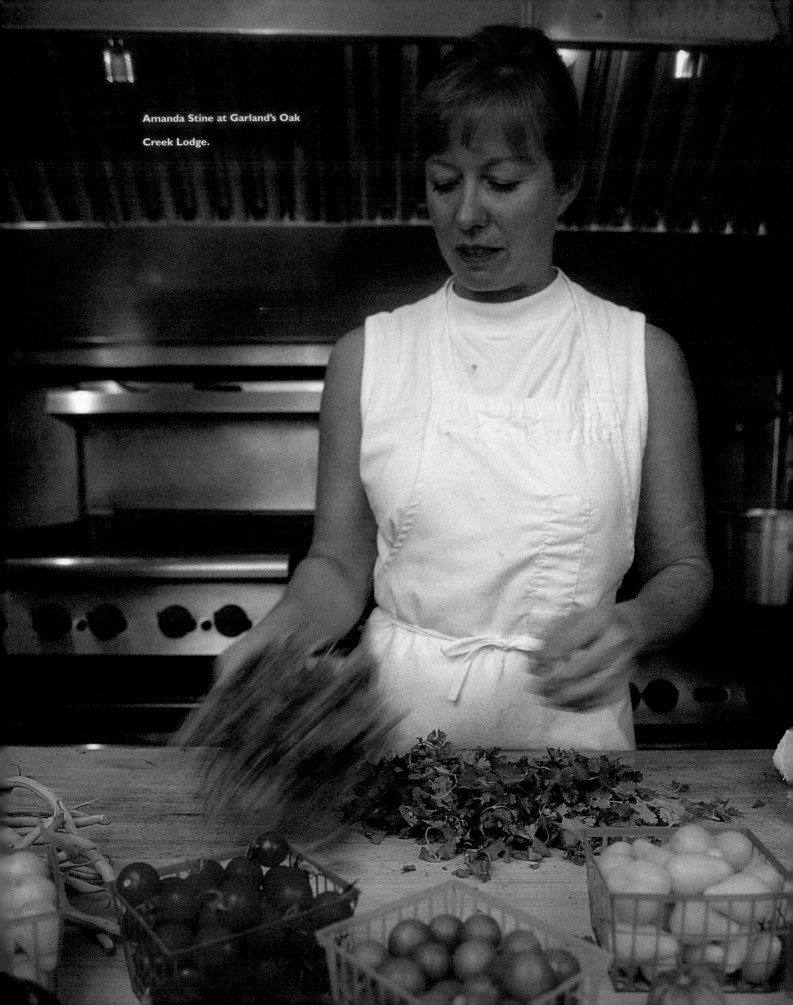

Amanda Stine at Garland's Oak
Creek Lodge.

CRISPY OAK CREEK TROUT

This breakfast entree is served at Garland's Lodge in Oak Creek Canyon and has always been a favorite with guests. At Garland's, the trout are accompanied by corn fritters and maple syrup. Serves 6

6 whole trout, 8-10 oz each, cleaned, rinsed, and patted dry
2 cups yellow corn meal
6 tablespoons butter
 kosher salt
 freshly ground black pepper
1/2 cup canola oil

Preheat oven to 250°. In a large skillet over medium heat heat 1/4 cup of canola oil to frying temperature. When the oil is hot enough to dimple but not smoking, test by flicking a pinch of flour into it. The flour should quickly foam but not burn. Place a strip of butter inside each trout (between the two halves) and sprinkle with salt and pepper. Dust outside of trout with cornmeal.

When oil is hot, place 3 trout in skillet and brown approximately 8 to 10 minutes. Turn fish and cover pan and cook an additional 8 to 10 minutes. Put on a sheet pan and keep warm in the oven. Add additional oil to skillet and repeat cooking procedure with remaining 3 trout. —AMANDA STINE, GARLAND'S OAK CREEK LODGE

CORN FRITTERS

Yields 12 large or 18 medium fritters

2 eggs
2 cups creamed corn
1/2 cup lowfat buttermilk
1/2 pound broken Saltine crackers (2 long sleeves from box, or 80 single crackers)
1/4 cup canola oil

In a mixing bowl combine all ingredients except oil and stir until well mixed.

In a large skillet, heat oil over medium heat until it crackles when adding a drop of fritter mixture.

Drop batter by the large tablespoonful into hot oil and cook 5 to 6 minutes on each side, watching closely to avoid burning. Do not turn too soon or they will stick. Batter may be made up to four hours in advance and refrigerated until used. —AMANDA STINE

ORCHARD APPLES WITH CHIPOTLE GLAZE

The combination of freshly picked apples and smoky chipotle chiles is a delicious accompaniment to nearly any pork recipe. Canned Chipotle Chiles in Adobo can be purchased in the Hispanic food department of most markets. Makes approximately 2 cups

1/2 cup sugar
1 1/4 ground cinnamon
1/4 teaspoon ground allspice
1/8 teaspoon ground cloves
4 medium red apples, peeled, cored, and sliced
4 tablespoons canola oil
4 teaspoons minced Chipotles in Adobo

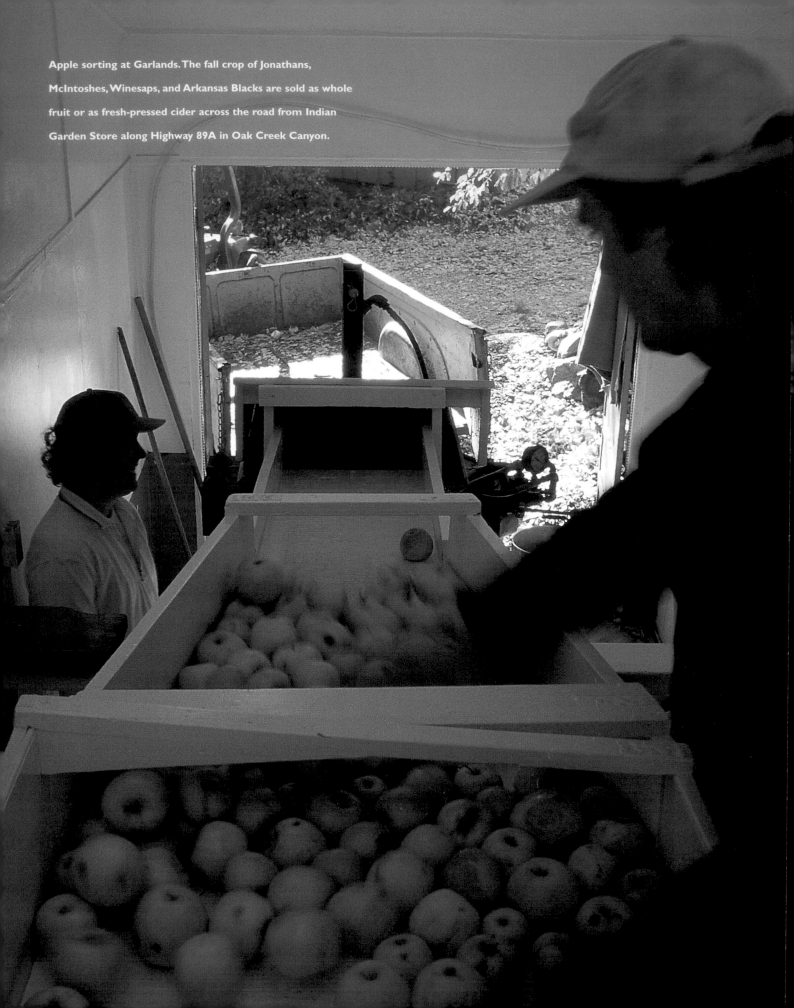

Apple sorting at Garlands. The fall crop of Jonathans, McIntoshes, Winesaps, and Arkansas Blacks are sold as whole fruit or as fresh-pressed cider across the road from Indian Garden Store along Highway 89A in Oak Creek Canyon.

In mixing bowl, toss sugar, cinnamon, all-spice, and cloves together with the apple slices. Heat 1 tablespoon oil and 1 teaspoon chipotle chiles in heavy skillet over medium high heat. Add 1/4 of the coated apple slices. Cook until coating caramelizes and apple slices are heated through, turning often, about 4 minutes. Transfer the apples to a serving bowl, wipe out the skillet, and repeat cooking process 3 more times to complete the apples. Serve warm or at room temperature over pork.

JALAPEÑO CHICKEN

Jalapeño chiles are dark green in color and zesty in flavor. Wash your hands carefully after preparation. Serves 4

1-1/4 cups purchased jalapeño jelly
4 tablespoons balsamic vinegar
1 cup loosely packed cilantro
2 tablespoons minced and seeded fresh
 jalapeño chiles
4 boneless and skinless chicken breasts

Set grill to medium heat. Mix jelly, vinegar, cilantro, and chili in a saucepan and stir over low heat until sauce simmers. Pour into a bowl, reserving 1/2 cup in saucepan. Coat chicken breasts with the sauce in bowl. Grill until done, basting with additional sauce. Spoon remaining glaze over grilled chicken and serve hot.

PEAR CHUTNEY

Pears are a commonly grown fruit in the Sedona area and were first introduced here by the original pioneer families. This spicy condiment is delicious served with game hens, other chicken dishes, or with meats seasoned with Southwestern Rub and grilled.

Artistic, whimsical, and a welder, Fuller Barnes created the architectural apple tree at the entrance to Sedona's Jordan Historical Park on the spot. Steel has been his medium since college days, and a shop full of junk parts and scrap metal provides infinite creative possibilities for his one-of-a-kind custom gates, furnishings, and hardware.

4 cups chopped pears
1-1/2 cups chopped onions
1 cup sugar
2 cups water
1-1/2 cups cider vinegar
2 cups chopped red bell pepper
1 cup currants
2 tablespoons minced ginger root
1 tablespoons minced garlic
1 teaspoon ground cardamom
2 teaspoon crushed red hot pepper
1 teaspoon each nutmeg, allspice, and cinna-
 mon

3 **whole cloves**
3 **whole sticks cinnamon**
1 **tablespoon kosher salt**

Combine all together in a saucepan and cook covered until very juicy. Uncover and cook gently until thickened and glossy. Correct seasoning for spiciness, tartness, and salt. If necessary, thin with water to proper consistency. —AMANDA STINE

SEDONA BRUNCH BURRITOS

These are great take-along food for a hike. Wrap individually in foil and then wrap again in newspaper to keep them warm. Carry in a backpack along with plenty of water and some fruit. Makes 12 burritos

12 **eggs**
2 **tablespoons butter**
1/2 **chopped onion**
1/2 **pound cooked ground-turkey breakfast sausage or other sausage**
1 **teaspoon salt**
1/2 **teaspoon pepper**
1/4 **cup each of chopped red and green bell pepper**
12 **9-inch flour tortillas homemade or purchased salsa**
2 **cups grated Cheddar cheese**
1/2 **cup chopped cilantro**

Beat eggs, onion, salt and pepper in a bowl. Melt butter over medium heat in a large skillet and add the onion and peppers. Cook until soft, approximately 4 minutes, and add the cooked meat and egg mixture. Stir over heat until eggs are cooked through. Warm the tortillas in a microwave or wrap in foil and heat in in the oven at 150° for 5 to 7 minutes. Spoon about 1/2

cup egg mixture onto the center of each tortilla in a lengthwise strip, leaving space at the ends. Top with a little salsa, cilantro, and cheese. Fold one side of the tortilla inward over the eggs, then fold in the ends, and then fold the other side over the eggs to create a tight envelope effect. Wrap individually in foil packets and keep warm in the oven until ready to pack in newspaper. If eaten at home, the tortillas can be placed in a glass casserole dish side by side, topped with additional cheese and kept warm in oven. Serve with more salsa and chopped cilantro. —PAMELA MORRIS

SOUTHWESTERN RUB

This mixture can be made ahead and stored in the refrigerator almost indefinitely. For a Southwestern flavor, rub on meats prior to cooking, sprinkle on salads, or add to various favorite dishes.

5 **dried New Mexican chiles, torn in pieces**
5 **dried Pasilla chiles, torn in pieces**
1 **dried cayenne pepper**
2 **tablespoons toasted cumin seed**
1 **tablespoon coriander seed**
2 **tablespoons dried Mexican oregano**
2 **teaspoons ground black pepper**
1 **tablespoon kosher salt**

Combine all ingredients in a spice grinder or clean coffee mill and blend thoroughly. Store in a cool place in a sealed jar. —JOHN AND SUSAN ETTLINGER

STEAKS WITH CHIPOTLE CHILE SAUCE

Chipotle chiles are jalapeños that have been smoke-dried over a mesquite fire. They add a great smoky taste to these grilled steaks.

4 filets mignon, each 1 inch thick
1 tablespoon olive oil
1 canned Chipotle Chiles in Adobo Sauce (available in the Hispanic section of grocery markets)
2 tablespoons minced shallots
2 minced garlic cloves
1/2 cup red wine
2 cups beef stock
1 teaspoon ground coriander
3 tablespoons unsalted butter
 salt and pepper

Coat the steaks with Southwestern Rub (directly above) and grill to desired doneness.

While steaks are grilling, Sauté the shallots and garlic in olive oil for about 1 minute. Add the red wine and boil until reduced to 1/4 cup. Add the beef stock, chipotle chile, and coriander. Boil over high heat until reduced to about 1-1/2 cups. Remove from heat, and whisk in the butter and salt and pepper. Serve over the grilled steaks.

Desserts and Drinks

APPLE PANDOWDY

The Oxford English Dictionary calls the origins of the word "pandowdy" obscure but we know it as an old, rustic American recipe for one-crust apple pie. The American Heritage Dictionary suggests that the dish was baked briefly and then "dowdied" by having the crust cut into the filling before the final baking. Serves 6.

4 large tart apples, peeled, cored and sliced 1/4" thick
1/4 cup sugar
1 teaspoon pumpkin pie spice
 juice of 1 lemon
3 tablespoons dark rum
1/2 cup unsulfured molasses
1 cup flour
1 teaspoon baking powder
 pinch of salt
1/2 cup sugar
1 small egg, beaten with 1/3 cup milk
6 tablespoons melted butter

Preheat oven to 350°. Butter a 9-inch ovenproof baking dish. Toss the apples with the sugar, pumpkin pie spice, and lemon juice. Spoon them into the dish. Mix the rum and molasses together. Pour over the apple slices and bake 20 minutes. Combine the flour, baking powder, salt, and sugar in a bowl. Add the egg, milk, and melted butter and stir well. Spoon the mixture over the apples and cut into the apples gently. Bake 15 minutes more. Serve warm, upside down, topped with heavy cream or vanilla ice cream. —JOANNA DEAN

Apple Pandowdy

CHOCOLATE SUCRE TACOS WITH RASPBERRIES

The ultimate chocolate fix for taco lovers!
Serves 8.

For the filling:

7 ounces good-quality semi-sweet chocolate

1 cup butter, room temperature

1-1/4 cups sugar

4 eggs

1 teaspoon pure vanilla extract

For the pate sucre:

1 cup butter, room temperature

1 cup sugar

2 eggs

3/4 cup Dutch process cocoa powder

3 cups flour

 shaved white chocolate for garnish

2 pints raspberries

To make the chocolate filling: Melt semi-sweet chocolate in a double boiler over low heat. Set aside to cool. Cream butter with sugar on high speed using an electric mixer. Add eggs one at a time and mix 10 minutes, until light and fluffy. Reduce mixing speed to low and add cooled chocolate and vanilla. Mix until blended. Pour into bowl and refrigerate until firm.

Chocolate Sucre Tacos

To make the chocolate tacos: In mixer cream together butter, sugar, and eggs on medium speed for 5 minutes. Sift together cocoa and flour. Slowly add flour mixture to butter mixture, blending thoroughly on low speed. Wrap the dough in plastic wrap and refrigerate until firm.

On a sugar-sprinkled pastry board, roll out dough into a large rectangle. Cut into eight 6-inch circles. Spray a metal taco utensil with nonstick vegetable spray. Fit a circle into the device by folding it in half. (Taco utensils, often sold in kitchen supply stores such as Williams Sonoma, are usually intended to hold corn tortillas in a U shape while they are deep-fried. Using the utensil for chocolate tacos allows you to create a desert taco shell with space inside for the chocolate filling.) Bake at 325° for 10 minutes. Repeat with remaining circles of chocolate dough. Cool to room temperature.

To assemble: Place chilled chocolate filling in pastry bag fitted with large star tip. Pipe into baked chocolate taco shells. (If filling becomes soft while piping, refrigerate until firm and continue). Sprinkle top of filling with white chocolate shavings.

Refrigerate until ready to serve. Dust dessert plates with powdered sugar. Place tacos on plates and garnish with fresh raspberries. —CARLA GASPER

TEQUILA SORBET

Tequila, used in many popular Southwest recipes, is a colorless liquor distilled from the agave plant. Serves 8.

1-1/2 cups sugar
3-1/2 cups water
3/4 cups tequila
1-1/4 cups lime juice
1 beaten egg white
1 thinly sliced lime, 8 pieces

Combine water and sugar in a heavy saucepan, bring to a boil, lower heat, and cook until the mixture reaches the consistency of syrup, about 5 minutes. Remove from heat and cool. Place tequila in pan, ignite with a match, and allow to flame until volume is reduced by one-third. Remove and cool. Combine syrup, tequila, and lime juice. Freeze the mixture. Remove from freezer when slushy and fold in the beaten egg white. Return to freezer until the sorbet is firm. To serve, dip stemmed glass in lime juice, then in sugar. Fill with sorbet and garnish with a slice of lime.

BLACKBERRY AMARETTO LATTICE PIE

Blackberry bushes growing wild in Oak Creek Canyon are heavy and lush with berries in late summer. Serves 6 to 8

4 cups fresh blackberries
1 cup sugar
1 tablespoon fresh lemon juice
5 tablespoons. cornstarch
1/3 cup Amaretto liqueur

Blackberry Amaretto Lattice Pie

Sedona Sunset Frozen Coolers

Dough for a double-crust pie

1 beaten egg yolk
1 teaspoon milk
1 tablespoon sugar
1 teaspoon cinnamon

Garnish: Fresh berries, mint sprigs, whipped cream

Preheat oven to 350°. In a large mixing bowl, gently combine the berries with the sugar. In a separate small bowl, mix lemon juice, cornstarch, and liqueur and stir until smooth. Stir gently into berry mixture.

Roll out one dough disk to 12-13 inch round on a lightly floured surface and transfer to a 9-inch pie pan. Spoon filling into the crust.

Roll out second dough disk on lightly floured surface to the same diameter and cut into 1/2 inch strips. Weave strips over top of berry mixture to form a lattice design. Trim crusts and crimp edges.

Mix together the egg yolk and milk and brush the mixture over the top crust.

Sprinkle with sugar and cinnamon. Bake 45 to 50 minutes until top crust is golden. Garnish with additional fresh berries and mint sprig. Top with whipped cream. —DOTTIE WEBSTER

SEDONA SUNSET FROZEN COOLER

To be enjoyed in the afterglow of sunset on a back portale.

Crushed ice
12 ounces vodka
1 twelve-ounce can frozen lime juice
2 tablespoons fresh lime juice
2 tablespoon canned condensed coconut cream
 Garnish: Lime slices and mint sprigs

Fill blender with crushed ice. Add vodka, frozen lime juice, fresh lime juice, and coconut cream. Blend until smooth. Pour into stemmed glasses and garnish with lime slices and mint sprigs. May be frozen until ready to serve. —DOTTIE WEBSTER

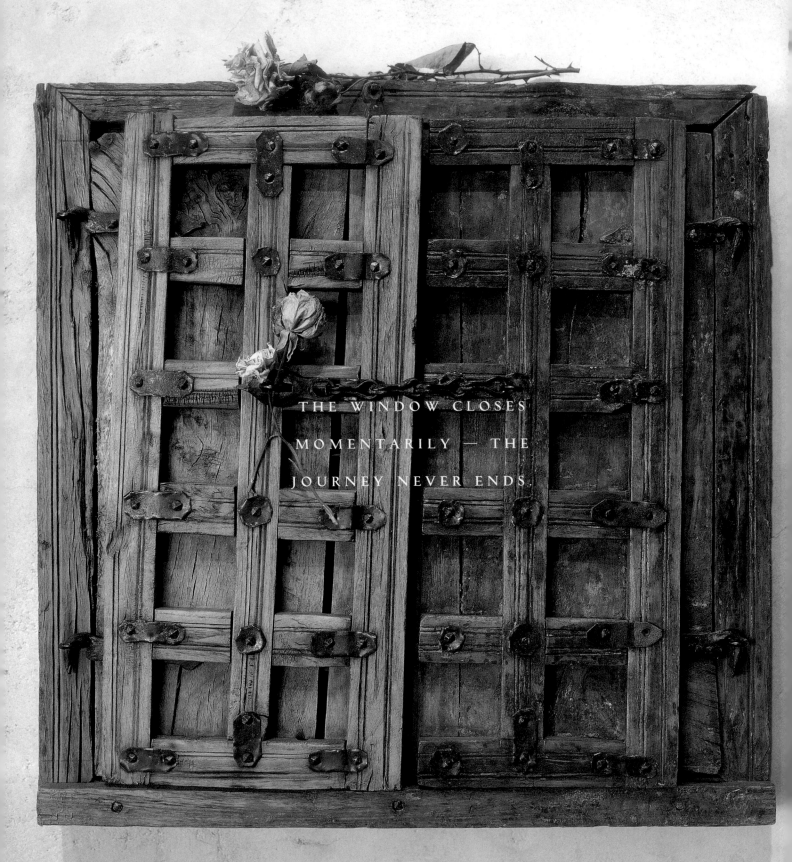

THE WINDOW CLOSES

MOMENTARILY — THE

JOURNEY NEVER ENDS.